D0438083

WHAT THE ERMINE SAW

ALSO BY EDEN COLLINSWORTH

*Behaving Badly: The New Morality
in Politics, Sex, and Business*

I Stand Corrected

It Might Have Been What He Said

WHAT THE ERMINE SAW

The Extraordinary Journey

of Leonardo da Vinci's

Most Mysterious Portrait

Eden Collinsworth

DOUBLEDAY · NEW YORK

Copyright © 2022 by Eden Collinsworth

All rights reserved. Published in the United States by Doubleday,
a division of Penguin Random House LLC, New York, and distributed
in Canada by Penguin Random House Canada Limited, Toronto.

www.doubleday.com

DOUBLEDAY and the portrayal of an anchor with a dolphin
are registered trademarks of Penguin Random House LLC.

Jacket art: *Lady with an Ermine* (detail) by Leonardo da Vinci.
DeAgostini / Getty Images
Jacket design by Michael Windsor
Book design by Maggie Hinders

Library of Congress Cataloging-in-Publication Data
Names: Collinsworth, Eden, author.
Title: What the ermine saw : the extraordinary journey of
Leonardo da Vinci's most mysterious portrait / Eden Collinsworth.
Description: New York: Doubleday, [2022] | Includes bibliographical references.
Identifiers: LCCN 2021057123 (print) | LCCN 2021057124 (ebook) |
ISBN 9780385546119 (hardcover) | ISBN 9780385546126 (ebook)
Subjects: LCSH: Leonardo, da Vinci, 1452–1519. Lady with an ermine. |
Art—Provenance.
Classification: LCC ND623.L5 A68 2022 (print) | LCC ND623.L5 (ebook) |
DDC 759.5—dc23/eng/20220222
LC record available at https://lccn.loc.gov/2021057123
LC ebook record available at https://lccn.loc.gov/2021057124

MANUFACTURED IN THE UNITED STATES OF AMERICA

1st Printing

To Nan A. Talese

If history were taught in the form of stories, it would never be forgotten.

——RUDYARD KIPLING

AUTHOR'S NOTE

I am neither a historian nor an art expert but have consulted a great many of both on the subject of this book. Only when no facts could be found did I engage in speculation.

WHAT THE ERMINE SAW

A QUESTION TO BEGIN

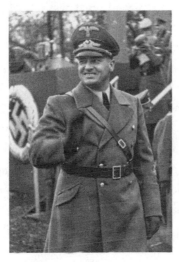

Put simply, Hans Frank did not look Aryan.

IT WAS FORTUNATE FOR HANS FRANK that he wasn't
expected to be an outward-facing example of Hitler's
conceived master race, because he lacked what the Nazis
considered desirable Nordic racial features. Instead, Frank
sat behind a desk in an office.

Frank sat behind office desk after office desk until he
rose in rank from Hitler's personal lawyer to the critically
important role of overseeing the expansion of Germany's
territorial base after its invasion of Poland in 1939. His

position afforded him a desk in a grand and ancient building in the Polish city of Kraków, and on the wall behind him hung a small painting. As Hitler's deputy, Frank worked diligently on several fronts: he implemented the deportation of Polish citizens to make way for German colonization; he enslaved what was left of the Poles; and he did what he could to eradicate the Jews. Murdering at a furious pace while complaining that his hand ached from writing so many death warrants, Hans Frank supervised the wholesale extermination in death camps that would kill 20 percent of the Polish population. He fled at the end of World War II, and Allied forces tracked him to his Bavarian vacation home; not far from where he stood, waiting to be arrested, was the small painting.

Why would this coagulation of human evil—dead to shame but aware that he was facing his end—refuse to part with the image of a beautiful girl holding a white ermine?

PART ONE

Soldiers of fortune, a cunning Italian duke,

a remarkable young woman,

and the rare genius connecting them.

ONE

SOME 530 YEARS AGO, a young Italian woman—not much older than a girl, really—sat for her portrait.

It was a customary practice in Europe to commission a noblewoman's portrait in anticipation of marriage—marriage being a transactional event with political or monetary value. The setting was a sprawling, opulent, Milanese *castello,* but the young woman's simply styled dress revealed that she was neither noble nor soon to be married. Instead of being depicted as something akin to an object, she would be well and truly the portrait's significant subject.

In a time when her sex was expected to harbor unexpressed opinions, the young woman diverted herself during the long stretches of sitting for her portrait by enlisting a circle of learned men with whom to enjoy intellectual conversation. Often they would do this in Latin—a devilishly complicated language whose alphabet is derived from the Etruscan and Greek alphabets and features a nominative, a vocative, an accusative, a genitive,

a dative, and an ablative. Some days, the young woman would recite poetry to the men or orate long passages by memory; on other days, they would debate philosophical issues in respectfully low voices so as not to disturb the concentration of the painter, whose focus was forensically trained on the purpose at hand.

The painter was not just an artist. Indeed, he eluded any number of categorizations, but if there were a central knot of his being, it was curiosity. His fascination with science often informed the methods of how he worked; by studying the anatomy of the human eye, he had gained an understanding of the relationship between light and the size of the pupil, noting that "the pupil of the eye changes to as many different sizes as there are different degrees of brightness" and that in "the evening and when the weather is dull, what softness and delicacy you may perceive in the faces of men and women." To benefit from this discovery, he would sometimes paint during overcast days or the early evenings when his enlarged pupils would have a sharper focus.

He was in his early thirties and strikingly handsome: tall, lean, with auburn curls flowing past his shoulders and a neatly trimmed beard. He had a perfectly straight, Grecian nose and deep-set, soulful eyes. There was a brio in his style of clothes, which were convention flouting in the best possible way. While most of his male contemporaries wore long garments, he dressed in rakishly short tunics.

As for his character, it was hard to read. He wasn't thought to be broody as much as self-absorbed. There was a meditative nature about him, and his facial expression

often rested in the unsettling border between open and not, making a reading of his thoughts difficult. He appeared most content when left on his own with his notebooks; on the other hand, he could offer himself to conversation with disarming ease and infectious charm. The combination of these two traits enabled him to portray the interior life of the subjects he painted while revealing very little of his own.

The painter's way of working required time, and his refusal to be rushed with a commissioned work often frustrated his patron, but so admired was he—so unrivaled were his talents—that he was granted as much time as was required. That said, the young woman and her retinue thought it odd that as they passed his easel while filing out of his studio after each of the sittings, they could see that no brushstrokes had been made on the wood panel where there was meant to be an emerging image. Unbeknownst to them, the painter had already conceived the portrait. In order to capture the fluidity of the young woman's grace before painting her, he had investigated the mechanics of how her head and shoulders would move as she turned. To illustrate his understanding, he drew eighteen rapid compositional sketches of a model's head in a revolving sequence.

Just as the painter took a systematic approach to his working methods, so too did he pay fastidious attention to its preparations. The wood panel on which he would paint the portrait was small—a mere twenty-one and three-eighths inches high and fifteen and a half inches wide. So that it would remain impenetrable to worms, he

instructed his assistant to wash it thoroughly with a solution of brandy mixed with sulfurous arsenic and carbolic acid. To fill the panel's tiny holes and close any of its thin vein-like cracks, it was covered with a thin paste of alabaster. The panel was sealed by applying a lacquer of cypress resin and mastic. Once the lacquer dried, a flat iron rasp was used to smooth away any remaining asperities. Only then did the assistant prime the wood panel with a layer of white gesso—a binder of sorts, mixed with a combination of chalk from bone and gypsum. This was the immaculate surface on which the painter made a preparatory drawing using charcoal powder. The drawing was meant to accomplish nothing more than outline a contoured likeness of the young woman. The rest—the remarkable—was still to come.

It was not the assistant who had moved the panel onto an easel, but the painter so that he could adjust it at his eye level. Under the easel was a centered table, reached easily from either direction. On the table were palettes and shallow cups of colors mixed with precisely calculated formulas. The formulas included certain minerals and seed oils judiciously selected. Nearby were paintbrushes. Some had a slight dusking of chalk on their tips applied the night before to prevent insect damage. The larger brushes were made of hog's bristles held together by a band of lead; the delicate ones were formed with squirrel hair and goose quill. A number of both kinds had been made with longer handles whose utilitarian purpose was to provide enough distance between the panel and the painter, enabling him to view the entire image without stepping back from it.

Accepting the commission to paint a portrait of the young woman would have obliged the artist to create a flattering impression of her. In this case, there would be no need to enhance reality. She was flawlessly beautiful. In a concession to one of the contemporary fashion trends at the time, gum arabic—a natural gum of the hardened sap from acacia trees imported from the East—smothered her long, shiny hair, which, wrapped around her face, gave her the appearance of a glistening lure. Running across her high forehead was a narrow long fillet holding in place a transparent veil that framed her delicate features. She was radiant: part child, part woman, with lips softened by a suggestion of innocence and clear eyes that had already learned much of life but were eager to see a great deal more of it.

The painter thought her too young to comprehend the world outside the *castello,* but he admired her intelligence and something she had that he did not—an extensive knowledge of Latin. There were days when he would grant himself the pleasure of listening to the poetry she recited, but none of her silken words would charm the charcoal outline on the wood panel into becoming the painted portrait for which he had been commissioned. That would require an entirely different language, one understood only by him and only when everything else in the studio fell away but his entire concentration. He was ambidextrous. His habit was to draw with his left hand but to use both hands when he painted.

It matters not at all which of his two hands reached for which brush resting on the table under the easel that held

in place the wood panel. What matters is that five centuries ago this simple gesture led to the creation of a portrait that, even now, does something very little else can do. It astonishes.

The painter was Leonardo da Vinci. "Learn how to see," had been his advice. "Everything connects to everything else."

It is clear from the young woman's entrancing gaze that something—or someone—has caught her attention. Still, she shows not the slightest sign of strain in the fleeting moment of turning away from the direction she was going in order to look back at that other person. There is a deep intimacy passing mutely between the young woman and someone we cannot see, and whoever that person is, they are more important than you—or for that matter anyone—will ever be.

Had your eyes told you these things as they studied the portrait, they would not have failed their assignment.

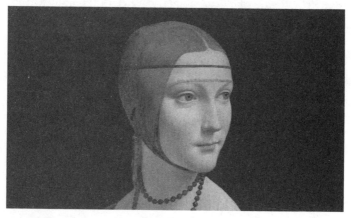

A glance to get lost in.

The young woman—with her sublime grace and guiltless beauty—seems to be relaying an unspoken message to just beyond the place we are standing. It is for this unseen person that the beginning of a smile plays across the corners of her mouth and passes over her cheeks to reach her eyes.

And what of us?

We are left with a multitude of unanswered questions about the enthralling young woman far away in time but exerting extraordinary power, and whose portrait is made more cryptic by an odd-looking creature cradled in her arms. The creature, too, is suggestive; its tiny claws grasp at a lush cloak that drapes around her as though holding secrets in its dark folds. With the creature's half-turned head facing the same direction as the young woman, and its eyes fixed on the same object, their slender bodies appear almost as a single serpentine figure. There is something slightly erotic suggested by the serenity with which the young woman is languidly caressing the creature's neck.

She is known simply as *Lady with an Ermine*. The year she was painted is believed to be 1490, though even that date is disputable.

———

Leonardo's genius unfurled during an era with changes occurring at an unprecedented rate: stunning technological advancements played out against the backdrop of social change and cynical self-interest; political divisions polarized people, setting them against each other; territorial fragmentation threatened to upend nations; the extravagances of the rich that flouted the privations of the poor

had been further exposed by a deadly plague. With acutely realized visions of the future, Leonardo wrote in his diaries about the insidious impact of men "fouling the lucid streams." His disobliging observations about humankind included a prescient warning that "men will throw down the great trees in the forests of the universe . . . there will be no creature on earth, under the earth, or in the water that they do not pursue, hunt down, spoil, and drive from one land to the other." Illustrating the perils of taking nature for granted were the turbulent images he drew of a wind-whipped, water-drenched world of impermanence. His uncanny prophecies of man's destruction were not only of nature but of each other, and he expressed his disheartened opinion of humankind in a series of caricatures that swelled into a gallery of grotesques. Despite—or because of—what he recognized as man's endless cruelty and ignorance, Leonardo chose not only to record ugliness and destruction but to create beauty, and *Lady with an Ermine* is perhaps the most beautiful of only four known portraits of women he painted during his lifetime. Two other people were responsible for why and how the painting came to be: the ruthless Italian tyrant who commissioned it, and its young subject, admired as much for her formidable intelligence as for her beauty.

Genius, power, beauty—each had its price.

TWO

IT'S EASY TO BELIEVE that *Lady with an Ermine* exists in a rarefied realm of its own. But the cold, bare truth is that it was paid for with the ill-gotten gains from previous generations of professional killers.

Between the ninth and the fifteenth centuries, what is now Italy was then a polycentric landscape consisting primarily of five regional city-states: the Duchy of Milan; the Republic of Venice; the Republic of Florence; the Papal States; and the Kingdom of Naples. These principal states were fragmented not only in territory but by diversities of climate and dialects. While each city-state advanced in wealth and organization, all five remained senselessly uninterested in joining forces to build a collective army, and in the event that neighboring countries encroached on their territory, they depended on foreign mercenaries for assistance—free agents of death who, unemployed after their own countries won or lost European wars, formed private mercenary companies that zigzagged across Europe taking advantage of political power vacuums wherever they sprang up.

Service terms for mercenary companies that crossed into Italian terrain were outlined in a *condotta,* a contract; the contracted leader—the mercenary captain—was given the title of *condottiero.* All parties benefited in ways that were circular: taxation within the city-states covered the expense of hiring mercenaries, whose protection spurred an impetus for trade and business that generated renewed wealth, from which taxes could be levied that provided the funds to continue to hire the condottieri for protection during spasms of violence in the region.

The condottieri were a culturally disparate group, but an Englishman from Essex could speak remorselessly for them all. John Hawkwood, a wolf in wolf's clothing, began as a minor player in the last gasp of the Hundred Years' War (1337–1453) and took to killing with the kind of gleeful determination that could easily be misunderstood for enthusiasm. He worked his way up by drawing on a lethal combination of feral intelligence and a diabolically black heart. His battlefield tactics included feigned retreats, deadly ambushes, and false information. When business was slack, he and his men would often camp close to an affluent town with the purpose of extracting a bribe for not attacking it. If the tactic failed or the payment proved insufficient, they would torch the town and hold its wealthiest citizens for ransom.

It would be easy to assume that a man who sought the barest pretext to kill, whose career path was littered with hundreds of slaughtered victims—one who, upon entering a room, would cause the temperature to drop—would make for bad marriage material. That wasn't the case with

Hawkwood. Not only was he married twice, but he married up: the second time to the daughter of the Milanese ruler, Bernabò Visconti, despite his previous attempts to kill various members of her family.

Hawkwood's massacres were long remembered as among the worst ever perpetrated in medieval times: his troops dismembered their enemies, sacked monasteries, raped women, and murdered children. But the forces of good did not punish Hawkwood. He died in 1394, extremely rich, at an advanced age, and from natural causes. Florence, his final and grateful employer, buried him with solemn pomp in a cathedral where he was recognized with a glorious monument. Far more enduring in the broader scheme of things, though, was the wealthy and powerful Visconti family, which rose to power during the Middle Ages and dominated the history of northern Italy in the fourteenth and fifteenth centuries in ways that included marriage alliances and lucrative contracts awarded by the Italian prince-bishops in papal territory, a favorite recruiting ground for enlistees eager to fight battles led by foreign condottieri.

Not all condottieri were foreign. By the early fifteenth century, a number of landless Italian knights had taken up arms. One was Giacomo Attendolo, who, in an acknowledgment to his strength, came to be known as *Sforza*.

Notable among the early generations of Italian condottieri were those whose skills on the battlefield combined with enough physical strength to spend days on a horse. Subsequent generations of the condottieri were less enamored with the protection racket. The more educated

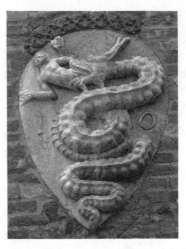

*The Visconti's coat of arms features the unnerving image
of a viper swallowing a child.*

among them learned that by employing diplomacy over force, they could avoid confrontations detrimental to their economic interests. The theory that war is a continuation of politics by other means makes it easier to understand why the most powerful and sophisticated Italian condottieri emerged from the murky corners of civic society as secular lords. Like the Roman emperors whose histories they read, these men became the founders of new Italian dynasties. The first perpetual Lord of Milan was a Visconti. A Sforza would take his place.

THREE

FRANCESCO SFORZA, one of Giacomo Attendolo Sforza's seven illegitimate sons, was a second-generation Italian condottiere who fought alongside his father. Francesco, legend had it, was able to bend metal bars with his bare hands. Such was the reputation he gained as a skilled field commander that the powerful alternatively sought to hire him and protect themselves from him. Bold as he was, even nerve couldn't explain how, after defending Milan from the Venetians, he turned around and laid siege to it—the very city-state that had paid him and his army. After capturing the Visconti's fourteenth-century Milanese fortification, he named himself duke.

Claiming the ducal scepter and wielding it were two very different things. Francesco managed the latter by establishing several crucial beachheads, none calling on his otherwise aggressive nature: he played upon the sympathies and loyalty of the Milanese public; he enlisted the support of a significant member of the Medici family in Florence; and, most remarkably, in order to bestow upon

himself further eminence, he married his way into the Visconti dynasty, despite its humiliating defeat at his hands.

Francesco appropriated the distinctive image of a viper that appeared on the Visconti coat of arms for one he designed on behalf of a Sforza dynasty in the making. While he was rebuilding the Visconti fortress into the grand Sforza *castello,* his wife, Bianca Visconti, concentrated her energies on rearing their children. Underpinning those efforts was her strong belief that a learned person could cultivate noble interests that lay beyond the narrow world. Sadly, her eldest son, Galeazzo, was a stark reminder that those closely positioned to disappoint often include your children. He was unsavory at an early age—a purveyor of lies with more than a whiff of criminality about him—but Bianca had to wait until he inherited the ducal title for him to surpass her most pessimistic expectations. Court gossipers were probably right when they attributed her death to poison administered on her son's orders.

Galeazzo's sadistic streak enjoyed a range of savage outlets: at one time he forced a poacher to swallow an entire hare alive; at another, he had a man buried alive, but only after the man was nailed to the outside of a coffin. Like a black inkblot, his indelible debaucheries spread into the principal Milanese houses where he would savagely force himself on wives and daughters before passing them on to his guards.

Putting an end to his reign of dissolution were three young noblemen, including one whose beloved sister had been raped by Galeazzo. In 1476, a day after Christmas,

the three men encircled Galeazzo during a public festival and took turns thrusting their daggers in him. When he pitched forward, dead, it was like the first among falling dominoes. His seven-year-old son inherited the ducal title. The boy's mother assumed the regency on his behalf. His uncle Ludovico eased her aside to become regent.

"I take up the burden of power," Ludovico said, "but leave the honors of it to my nephew." Despite his public declaration, Ludovico intended to remain on the throne. Unlike his brother, Galeazzo, who consumed his rightful heritage in wanton entitlement, Ludovico had to establish himself as a credible figure. He accomplished this with forethought, adaptability, tenacity, and cunning. It's believed that the reference to Ludovico as *il Moro,* "the Moor," was due to his dark complexion. Equally likely was the menace conveyed by his pitch-black watching eyes. If you look closely at Ludovico's image, you'll see an immobile expression holding in place the inscrutability of a man comfortable with dissembling.

Playing for the high stakes of a dukedom to which he was not the lawful heir, Ludovico bided his time in plain sight. *Merito et tempore* was the motto he chose as the *de facto* Duke of Milan, suggesting either self-restraint or glib irony, for he had already proven that all good things come to he who waits.

In his role as regent, Ludovico had a hand in virtually every aspect of Milanese life: from the law to the collection of taxes; from the administration of justice to the negotiation of labor oversight. However, he didn't confine his attentions to politics and commerce, and this would

have surely pleased his mother, for she had saturated his education with the humanities.

As a boy, Ludovico was a lover of books and artistic pursuits. As a man, he was determined to create a perfect Milan. Ludovico, the boy, was tutored by a leading humanist scholar. Ludovico, the man, decided at some point to unburden himself from carrying the extra weight of morality: there was—and still is—a deep suspicion that he had his defenseless nephew killed in order to invest himself as the Duke of Milan.

Because Ludovico was capable of simultaneously presiding over the demise of his young nephew and the most productive stage of the Milanese Renaissance, his interworkings make for a challenge to understand. Doling out virtues and faults in equal measure, he was generous but withholding, self-confident and not, well-wishing and just as easily unrestrained by regret or guilt. There seems no way of synthesizing Ludovico's character. His outward appearance is easier to consider.

To convey his political aims to the public, Ludovico made a point of being seen in clothes that featured the colors of his family's coat of arms—the same colors from the Visconti's coat of arms. In so doing, he was placing an emphasis on noble lineage and reinforcing his claim to have rightfully inherited the duchy. Unfortunately, Ludovico's coordinated attire did very little to enhance his physical attributes. He was a short man: his posture had given up and settled into a permanent, round-shouldered slouch. He had a notably ugly face that featured a domed forehead, a complacent double chin, and a thin, hard mouth.

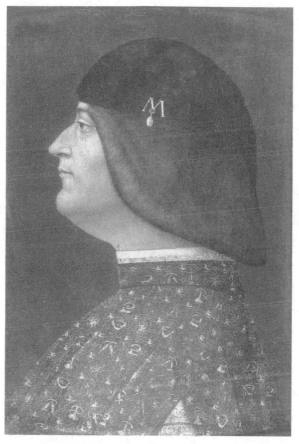

Ludovico Maria Sforza, known as the Moor.

With no getting around his lack of physical appeal, Ludovico tried to gain the upper hand through extravagance. Egged on by the confidence of his station as regent, he gravitated toward ostentatious displays of wealth. His court took on a brash, lavish tone—so much so that the clergy felt a need to set down sumptuary laws. But it seems

that not even the church could moderate Ludovico's appetite for costly fabrics, for he continued to peacock in plush velvets that showcased elaborate needlework. His courtiers were decorously attired in the finest silk; livery for his pages announced itself in fruity colors.

Although Ludovico's court stayed on sartorial message, those in his employ were not dreamy-eyed about the man himself: beneath his frothy outward trappings was a heart of flint. Complex, volatile, an idealist who was corrupt, a superstitious schemer who would never sacrifice advantage to principle, this same man was capable of recognizing beauty, and to celebrate it, he filled his court with men of letters and the arts. Under Ludovico's rule, the Milanese court became second only to the Florentine house of Medici, which had been the catalyst for an enormous amount of arts patronage in Italy.

Florence had positioned itself as a merchant republic by establishing trade routes with Byzantium, Arabia, Syria, and Egypt. Florentine wool guilds provided the Medici wherewithal to establish a textile business. The city's trade connections enabled the export of their goods to markets in Europe and the Near East. Having created a double-entry bookkeeping system for tracking credits and debits, Medici business was the earliest to use the general ledger system of accounting. It was the family's strategically astute decision to shift from textiles to financial services that brought untold wealth. While the Sforza dynasty (from *sforzare,* to exert force) lived up to its name, often with methods of brute force, the house of Medici accumulated political power by thriving financially and with a

steady hand. By the fifteenth century, the Bank of Medici was the largest in Europe.

As a source of progress, wealth has always sought outlets, which is why economic prosperity is one of the preconditions of art. Commissions resided primarily with the church during the Middle Ages; next was the aristocracy; and right behind them were the merchants and bankers. The Medici underwrote Florentine painters, sculptors, goldsmiths, architects, and engineers. Their patronage of music made possible the future invention of the piano and the development of what would become acknowledged as opera. As a result of the house of Medici and its contributions, Florence was transformed from a republic of wealthy merchants to a financial center with real political power and a cultural haven that boasted hundreds of churches and monasteries housing libraries of classical learning. The city's infrastructure improved, too. Five magnificent bridges spanned its river, the Arno, and its meandering medieval alleyways were replaced with wide, smoothly paved streets.

Unlike Florence, whose architecture emulated the sensibility of ancient Athens, Milan took on a more exotic quality under Ludovico's rule. Stealing the throne from his nephew instilled in him a paranoia of the conspirator's dagger, and his instinct was to fortify his political position with the flourishing Milanese industries of craftsmanship and workshops that delivered the luxuries required in a time when abundance equaled strength.

Ludovico was aware of the impressive advancements sweeping through other dukedoms, and he was also aware

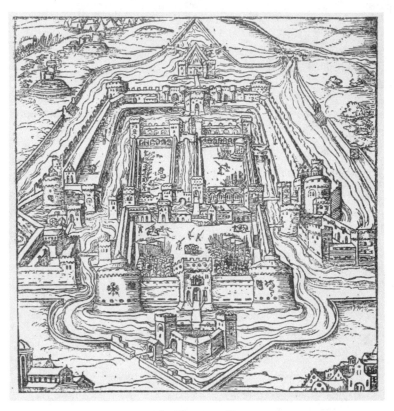

The Sforza castello.

that his ill-supported title required him to be more than expensively costumed, so he imported a glittering array of illustrious architects, civil engineers, sculptors, painters, cartographers, and technical designers to the city

In 1482, one such man, skilled in all of these endeavors, arrived at Ludovico's Milanese court.

FOUR

LEONARDO DA VINCI—arguably one of history's most resourceful geniuses—was the unwanted result of casual sex between a local peasant girl and a young man from a prosperous family. Both were from Vinci, a small hill town not far from Florence with winding cobblestoned streets, wooden shutters, and spindling trees. It was in this village that Leonardo was conceived and surrendered by his mother as an infant to his father's family.

In an era referred to as "the age of bastards," Leonardo's illegitimate birth would not have involved any injury to his future: his eighty-year-old paternal grandfather set down a few basic details unapologetically.

"A grandson of mine was born, son of Ser Piero, my son . . . his name was Leonardo."

The entry of birth, though brief, was followed with the name of the priest who baptized the newborn and a list of the people present at the ceremony.

Leonardo's grandfather had been a notary of repute, as had his great-grandfather. Leonardo's father also entered

the profession and married the daughter of another notary family. While the couple established their residence in Florence, Leonardo remained in Vinci with his grandparents, whose stolidly middle-class household provided a stability of routine but no formal education. The lack of structured schooling makes the abundant body of Leonardo's entirely self-taught knowledge almost unfathomable. He was an irrepressible force of nature and fortunate enough to have been nurtured in a time that was daring his country further and further. Revolutions in the sciences and the humanities tend to occur in clusters of extraordinary individuals: Giotto, Michelangelo, Galileo, Dante, Machiavelli, Marco Polo, and Columbus—all were Italians, each with a key role in paving the way for the future.

Leonardo's artistic creativity was irrefutable against the generational backdrop of the family's conventional profession. It's alleged that when, as a boy, he was asked by a local farmer to design a wooden sign, he set about capturing snakes, bats, and lizards found near the house—all to be obsessively studied, for he had already conceived the sign to be a dragon-like creature wriggling out of dark craggy rocks. Decades later, his notes would suggest that "if you wish to make an imaginary animal invented by you appear natural, let us say a dragon, take for the head that of a mastiff or hound, for the eyes a cat, and for the ears a porcupine, and for the nose a greyhound, and the brows of a lion, and the temple of an old cock, the neck of a terrapin."

Assuming the story of the sign is even vaguely accurate, it hinted at the often-extravagant preparations Leo-

nardo made later in life that were grander than his original assignments. It also spoke to the genuinely joyful spirit of inquiry he would always possess.

The death of Leonardo's grandfather came the same year that his father's wife died in childbirth. Leonardo joined his father in Florence, where, at the age of twelve, he began to prepare for a trade as apprentice to Andrea del Verrocchio.

Trained as a goldsmith, unsurpassed in his skill of rendering ornamental detail, and known for his industry and perseverance, Verrocchio, with his rigorous craftsmanship, cut a path toward a number of artistic pursuits. His studio was not just a workshop devoted to paintings and statuary; it was a factory of sorts. Nothing about the work environment might have suggested glamour. The space was prob-

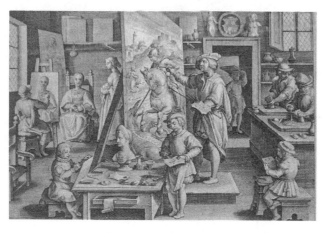

A fifteenth-century Italian workshop, depicted here cleaner and more orderly than was likely.

ably dirty and noisy—more utilitarian than inspired—and it likely consisted of a large, open ground floor separated from the outside with an awning, under which were samples of the studio's wares. Inside, Verrocchio, along with sometimes up to a dozen of his employees and pupils at various levels of apprenticeships, could be found toiling on a wide variety of deliverables that ranged from paintings, sculptures, mechanical contrivances, musical instruments, theatrical costumes and stage sets, tombstones, and metalwork, including suits of armor.

In our mind's eye, we tend to see Leonardo as he appears in the iconic, red-chalked Turin drawing that surfaced in the early nineteenth century: an old man with deep lines crisscrossing his face, winged eyebrows, and wispy hair. Earlier images of him testify that he stayed handsome into middle age, and it is said that as an adolescent he epitomized youthful male beauty: a number of art experts believe him to have been the model for Verrocchio's 1466 bronze statue of David, the biblical hero who felled a giant with a well-thrown stone.

While the apprentices who assisted Verrocchio would not have ventured to sign their names to the studio work, Leonardo often did just that by placing tangles of *vinchi* in the pictures; Vinci, Leonardo's town of birth, comes from the word *vinchi,* the reeds woven in the countryside of Tuscany. His other method could be seen in the L and V shapes of his subjects' bent arms in a picture's composition. At a later time, he would devise a deaf alphabet and position the fingers of the pictures' subjects in such a way as to signal his initials. One of the more obvious traces that

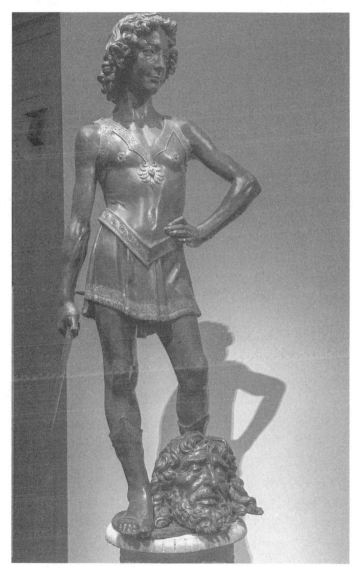

*Leonardo, as the triumphant David, whose self-confidence
seems to be flirting with arrogance.*

survive from this stage of his life was what he scrawled on the back of a drawing. Dated 1473, it declares in a fleeting moment of contentment, "I am happy."

Patronage of the arts was responsible for a large part of the beauty during the Renaissance, but no illusions should be had about the status of the artists. They were treated little better than workmen, bound hand and foot to deeds that, when signed, often provided just enough payment to cover the costs of purchasing materials, with the balance paid once the client approved of the completed commission.

Leonardo was—and always would be—hopeless with money. Only when he was at a temporary loss for it did he consider it at all, and even then he resented its intrusion on his creativity. He didn't like deadlines either but had no choice but to adhere to them while working in Verrocchio's studio, where the first painting he conceived and painted entirely on his own is likely to be *Madonna and Child with Flowers*. It went missing for centuries before reappearing in Russia.

At twenty-one, Leonardo enrolled as a member of the city's Painters' Guild. By the time he was awarded independent commissions, he had become an instinctive procrastinator. He began no more than twenty pictures in a career that lasted nearly half a century; of the twenty, fifteen are agreed to be entirely his; of those fifteen, four are, to some degree, incomplete. His stubborn resistance to finishing the work he began was due to an incessant curiosity. This overriding characteristic would have led to the career failure of any other artist, but Leonardo was something more, and it defied summary.

His personal life was elusive. Working alongside his fellow artists should have given Leonardo a sense of camaraderie and fellowship; instead, he became a master at concealing his personal thoughts. Little is known of his attachment to any one human being; if, as has been suggested, he found satisfaction of an intimate nature in the company of men, it wouldn't have been considered unusual in fifteenth-century Florence: the word *Florenzer,* or Florentine, came to mean "sodomite" in German. Despite the city's far-from-secret reputation, sex between two or more men was illegal, and a dedicated force, nefariously named "Office of the Night," encouraged citizens to place anonymous denunciations in a box, or *tamburo,* located in Palazzo Vecchio, the town hall. Leonardo was in his mid-twenties when he was identified by an unnamed accuser for immoral practices. After being summoned and interrogated, he was acquitted.

In his relentless pursuit of id, ego, and superego, Sigmund Freud was eager at one time to analyze Leonardo's life in homoerotic terms. True, Leonardo spent his working days with other male assistants and apprentices. True, the figures in his paintings are of fungible gender. And, yes, his notebooks provide a few accidental glimpses; scattered throughout them are obscured images suggesting that Leonardo might not have been sexually binary. Regardless of whether he was emphatically gay by the standards of later centuries, evidence that he was self-aware appeared as a notation in his journal: "It is easier to resist at the beginning than at the end." Obvious, as well, is that he was one of love's victims, for another of his entries reads, "If liberty is dear to you, may you never

discover that my face is love's prison." What is also certain is that Leonardo didn't separate his artistic life from his scientific or personal life, and, like so many of his plural interests, he could have been boundary crossing within the landscape of sex, detaching himself from the pursuit of it in order to focus on his wider curiosity of what he considered the mysterious workings of the human body. No one would endeavor to argue his gender-neutral take on the penis, which he noted "follows its own course . . . and sometimes moves without permission or any thought by its owner." Regardless of his proclivities, Leonardo's true nature revealed itself in his accumulation of knowledge. "The acquisition of any sort of knowledge is always useful to the intellect, because it will be able to dispense with useless things and preserve the good," he wrote, which explains why the commissions he received were waylaid by his convoluted campaigns of trying out other things that had little or nothing to do with the commissions per se. His analytical vision came from a constant questioning of the world, and determined to offset his lack of classical learning, he located books in a time when printing was still in its infancy. His private library would come to include the Bible, the Psalms, Aesop's fables, and Dante, along with various books on natural history and mathematics, anatomy, astronomy, and botany.

His impressive collection of books notwithstanding, Latin remained the hallmark of social status at the time, and Leonardo's lack of it kept him from the inner circles of the Florentine courts he served. He must have felt the sting of being judged when he wrote, "I am well-aware

that certain presumptuous people think they can slight me because I am not learned, but though I cannot, like them, quote from all the best authors, it is better and more praiseworthy to be well-read in the book of experience, the teacher of the teachers. These men strut about, puffed up and pompous, clothed and ornamented with the result of other people's work, not their own."

Despite the resentment Leonardo expressed toward the Florentine courts, his experiences within them provided a working knowledge of the mechanics of great palaces—a knowledge that would serve him with what was next.

A *next* there had to be, for despite the immense talent shown in his youthful paintings, Leonardo had failed to establish a lucrative position for himself in his native city.

FIVE

BATTERED FROM WAVE AFTER WAVE of barbarians tramp-
ling across the Alps, the city-state of Milan emerged
more universal than Italian, ruled by militaristic strong-
men. The Visconti crowned themselves hereditary dukes.
The Sforza dynasty replaced them.

Having left Florence with unfinished commissions and
in debt, Leonardo wrote, "When Fortune comes, grasp
her without risk and from the front, for, at the back, she
is bald." He must have had that in mind while composing
his letter to Ludovico, who, at the time, was still Milan's
regent but who had already acquired a reputation as a gen-
erous patron. Leonardo listed the many and eclectic tal-
ents on offer. He described inventions of war machinery
and how he would engineer bridges. He highlighted his
musical skills on various instruments and wrote that he
could design architecture of all types, as well as carry out
sculpture in marble, bronze, or terra-cotta. At the end of
the letter—almost as a throwaway—he mentioned that he
could also paint.

The two men were the same age—thirty. To Ludovico, Leonardo's visible talents would be considered a mirror of his own prowess as a leader. To Leonardo, who was a marvel of itchy intelligence that could take anything on as its object, Ludovico was not a regent but an opportunity to pursue his own countless interests.

———

Leonardo had a sly wit but was also unfailingly courteous and a model of tactful restraint when it was called for. He was an enthusiast of jousting, fencing, and swimming. Endowed with the distinction of height and a confident carriage, he was wonderful looking, impeccably and stylishly dressed, and had a great pair of legs in a time when fashion dictated that men wear tights. In short, it was impossible for him to go unnoticed when he took up residence in the Sforza *castello*.

Despite Leonardo's triumphs in court, his advancements—indeed, advancements in general during the Renaissance—were felt by only a fraction of Italy's population in a world that was becoming richer but not fairer. When Leonardo drew what he imagined to be the sea off the coast of Tuscany from an aerial perspective of birds, thousands of his fellow humans below were living in Milan's overcrowded districts, made up of narrow lanes with only the occasional weak shift of sunlight. Given the dank and shadowed passageways, the squalid rubbish piles left to decompose in the open, and the chamber pots emptied every morning from the windows overlooking the streets, little wonder that the outcome was a series

of bubonic plagues. Disasters are unequally destructive, and when quarantining the sick failed to slow down the plagues, Ludovico and his court did what the affluent do when confronted by a pandemic: they utilized the exclusive inoculate of secondary real estate and decamped for the country.

Leonardo, who stayed behind, envisioned a different Milan, and then he designed it. Grasping the consequences of the city's lack of sanitary arrangements—and developing solutions—he sketched lavatories with revolving windows for ventilation and underground canals to carry away human waste. He devised lifting gear that would operate by air pressure and take water to the top floors of houses. He invented new methods of heating, which included stoves and ovens.

It took the plague two years to dispose of a third of Milan's population before retreating. Ludovico passed through it unscathed and then declined to fund any of the ambitious infrastructure plans for the city that Leonardo submitted. Leonardo didn't care as much as one might have thought. This would continue to be the case with most of his other initiatives that failed to translate into actual terms of application. For him, nothing exceeded possibility, and he filled his portfolios and journals with ideas that described innovations hundreds of years before their invention: from a flying machine to swimming belts in order "to save lives at sea"; from a method of measuring the winds to one of counting the speed of ships. In possession of unflagging energy, a combinatory brilliance, and the inclination to go off on tangents, Leonardo had powers

of observation that remain inexplicable even today. How could he possibly have seen that the dragonflies around the moat of the Sforza *castello* "fly with four wings, and when those in front are raised those behind are lowered," when confirmation of that fact required the use of slow-motion photography some four hundred years later? Still at a loss to fully understand, one expert has suggested that Leonardo's visual acuity could inexplicably freeze-frame the insect's motion.

His notebooks, with their seventy-two hundred pages of cross-disciplinary brilliance, are the greatest record of creative curiosity ever produced. Keeping dozens of interests at play and armed with almost boundless gifts, Leonardo mingled one with the other in the inventions

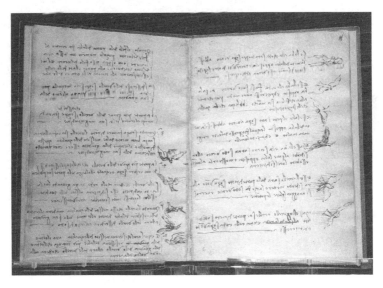

Even at his feverish pace, Leonardo would have needed many lives in order to think out his thoughts to the end.

outlined on the pages of his notebooks—all protected by left-handed mirror writing the uninitiated world would not understand. Given equal weight to his inventions were his inquiries. Few would not be intrigued by the reminder he wrote to himself in one of his notebooks: "Describe the tongue of a woodpecker."

Military inventions, anatomy, architecture, astrology, botany, cosmography, geology, geometry, mathematics, medicine, military arts, philosophy. While Leonardo pursued the varying interests that sprang from his unappeasable curiosity, his patron was busy enjoying the sexual perks of his title.

SIX

LUDOVICO'S HISTORY WITH WOMEN was, at best, questionable. When his notorious brother, Galeazzo, was the duke, the two shared a mistress. Her deed of gift included a clause forbidding her to have sexual intercourse with her husband without written permission from Galeazzo. Highlighting the male instinct of ownership was the provision that there would be no objection to the woman bearing Galeazzo's children and those of Ludovico. Given the open-ended cynicism reflected in such an agreement, one might appreciate just how unlikely would be Ludovico's commitment to any woman. His one grand exception would be the beautiful young woman in the portrait painted by Leonardo. She was most probably Cecilia Gallerani.

Cecilia was from a good but not rich family: her mother was the daughter of a noted law professor; her father—a financial agent attached to the Milanese court—died when Cecilia was seven. The required age for a girl to become a bride was twelve, and according to documents Cecilia might have been ten at the time a contract of marriage was

negotiated between her brothers and twenty-four-year-old Stefano Visconti.

That Cecilia's arranged marriage never took place might have been due to her cash-strapped brothers' inability to make the final payment some two years later. Though their names appear on the annulment document, it was Cecilia who filed the petition against Stefano for undisclosed reasons that would extricate her from the planned union. To ensure that there would be neither public disgrace nor private dishonor, the document included a reference to her purity.

Virginity can be bartered, stolen, or lost, but once gone, it is irretrievable. Cecilia understood that chastity was expected of her, but she refused to allow that nonnegotiable requirement to prevent her from the agency that came with intellectual pursuit. She insisted on receiving the same lessons as her brothers.

Hungry for experiences, open to possibilities, quick, tenacious, proud, witty—Cecilia was exceptional, so it would not be taking credit away from her by pointing out that in the spirit of the Italian Renaissance, girls from an educated family were almost always allowed a classical education, and that was the reason many brilliant courts in Italy featured cultured women at their centers.

If the archived documents are accurate, Cecilia would have been no older than twelve at the time Ludovico's wandering eyes alighted on her and she traveled to Milan under his protection. This might explain the unusual circumstances of her initiating legal proceedings that disengaged her from the possibility of marrying into the Visconti family.

Regardless of how, exactly, Ludovico's introduction to the alluring Cecilia occurred and when he eventually moved her to an unspecified location on the outskirts of Milan before relocating her to his *castello,* evidence of their liaison came in the form of a pregnancy. By then, Cecilia had not only managed to plant her affections in Ludovico's reputedly arid heart; she'd also forged a brilliant path through the thorny labyrinth of his court.

Those who hold the pen often choose history, and it should be said that Cecilia merits more than the footnote that history grants her. She knew languages (ancient Greek among them); she studied philosophy and was able to master sophisticated debates in Latin. She wrote poetry and composed music. Drawing on an infallible memory and the full range of her abilities at the improbable age of thirteen, Cecilia created a salon for leading artists, poets, and philosophers—the first of its kind in Europe, it is said. The respect given to her by Milan's intelligentsia filled Ludovico with pride. Admiring and loving her equally, he wrote that she was "candid and beautiful and more than I could ever desire"—this from a man allergic to sentiment.

Ludovico's startlingly poignant love for Cecilia would have required him to step out of character. The reasons he was willing to do so are evident in Leonardo's portrait of her. They emerge from his monochromatic underpainting: the foundation from which he would create volume and depth out of flatness with color. Leonardo used oil paint recently introduced in Italy from northern Europe. It dried slowly, and by dabbing it, he created the buttery flesh of Cecilia's neck; by blending it, wet on wet, using his finger, he modulated the shadows of her robe. Using a

technique he pioneered called *sfumato* (meaning "smoke"), he was able to soften contours with the haze of transparent glazes in successive layers and in a deliberately narrow and muted tonal range. This produced a sense of unity to the portrait's elements. It also reflected light and dark from underneath its layers, which created dimension.

In the artistic equivalent of Coca-Cola's secret recipe, scientific analyses reveal that the formula for Leonardo's paint included the ingredients egg yolk, linseed oil, and rosemary oil. Added to the oil concoction were materials and pigments. They had been delivered to Leonardo's studio in their raw forms of chunks and granules before being ground to a powder with a mortar and pestle. In the case of *Lady with an Ermine,* he would have used ocher, umber, indigo, green earth, red dye made from the root of the madder plant, vermilion, carmine, sienna, and Indian yellow coming to Milan from Calcutta. The vivid ultramarine blue of Cecilia's robe would have come from crushing imported lapis lazuli, which, dug in limited quantities from mines in Afghanistan, was valued in weight almost equal to that of gold.

Leonardo made Cecilia so palpably real with paint that we are able to imagine the faint pulse at the base of her throat and can almost hear her breath, but what he achieved is more than artistic precision. The portrait is not just a visual transmission of what she looked like; it's also a psychological narrative. By capturing Cecilia in a single moment of time—just as she was turning—Leonardo not only created something original in portraiture; he revealed Cecilia as the dynamic being she was.

Though her precise age when she met Ludovico has never been confirmed, there's evidence enough to suggest that Cecilia had barely left childhood when her future became dependent on pleasing him: an unacceptable concept in contemporary terms, yes, but within the context of its own time, no—it was not. To single out a circumstantial fact pegged to a particular period of time and then hang a judgment on it is wrong-minded. Cecilia was hardly a trampled flower: she likely believed that love for a man should be part of life but not its sole purpose; and she managed to take control of her own life in the ways she could enjoy—adjusting it between her intellectual pursuits and sensual pleasures.

Prematurely initiated into womanhood, Cecilia appears in her portrait with a vigorous willingness—even eagerness—to navigate its swirling eddies. Leonardo acknowledges her inarguable beauty, but he also makes clear that she is not dependent on her looks; indeed, the impression she leaves us with is that she is so self-possessed as to be untroubled by anything at all. It's evident by the frankness of her glance that she is not feigning an absence of desire, nor does she pretend to be powerless. Even without making eye contact with us, Cecilia tells us that she is not someone in the story of another but triumphantly and solely herself. We could do worse than to image her as the sprightly, slightly naughty, but confident younger sister of Mona Lisa, painted some fourteen years later.

SEVEN

CECILIA WAS THE OPENLY ACKNOWLEDGED mistress of a powerful duke: her rank as Ludovico's *prima favorita* offered not the slightest hint of coyness. "Highly honorable" is how he described her, adding that she was "all that man would desire."

Unfortunately for Cecilia, diplomacy, political security, and financial advancement in Italy came primarily from matrimonial alliances, and Ludovico was expected to honor an obligation waiting to be fulfilled in the northern province of Ferrara, which grew to prominence under the rule of the Este family.

The d'Estes and the Sforzas had always been on good terms, but to forge a stronger alliance founded on favorable and well-ordered conditions, it was agreed when Ludovico reached his mid-twenties that he should enter into a marriage contract with Isabella d'Este. She was six years old at the time this decision would have been made for her. Daughters of nobility were not as valuable as sons, but they were deployed on a regular basis as useful tools, which is why by the time Ludovico communicated

his proposition of marriage, Isabella had already been intended for Francesco Gonzaga, the future ruler of Mantua, the capital city in the northern region of Lombardy. But Isabella had a younger sister, Beatrice, and at the age of five she was promised to Ludovico with an understanding that the official nuptials take place when she reached fifteen.

The d'Este sisters were impeccably credentialed. Their father had distinguished himself as a genuinely interested patron of arts and letters; their mother, a daughter of the illustrious king of Naples, was known to be "singularly intelligent." Unfortunately, bland is the best one could do with her physical description: she was short and squat and had small eyes. Hoping that his future bride didn't take after her mother in this regard, Ludovico used the only method of due diligence available at the time: he commissioned the sculptor Giovanni Cristoforo Romano to travel to Ferrara and carve a bust of Beatrice.

In executing what most probably had been commissioned in 1490, Giovanni made a point of focusing on the delicately elegant band that gathered Beatrice's hair. He dedicated that same tastefulness in rendering the motifs of fabric draping over her shoulder. When it came to Beatrice's face, Giovanni stayed a charitably safe distance from any real detail.

For Ludovico to compare Beatrice to Cecilia, he need only to gaze upon the painting hanging prominently in his private apartments at the Sforza *castello*. *Lady with an Ermine* was a worthy testament to Cecilia's unsurpassed beauty, spontaneous elegance, and hushed confidence.

It wasn't only Ludovico who admired Cecilia.

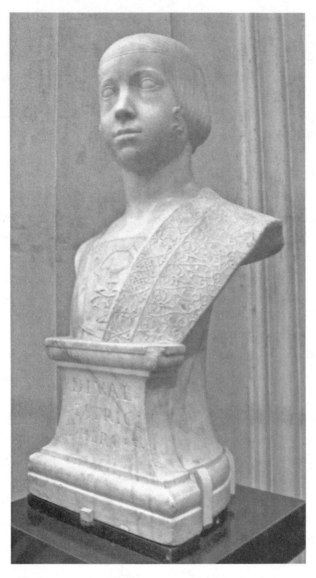

Beatrice's bust, now at the Louvre, makes reasonable the conclusion that she did not dazzle with her looks.

"To her bright eyes the sun seemed a dark shadow," regaled Matteo Bandello, a great writer of the time, who commended Cecilia for her poetry, her musical skills, and her orations delivered at the salons over which she presided, where "the most superior intellects in Milan, as well as such foreigners who happen to be there, are to be found in her company." Bandello's enthusiastic report continued: "Here, soldiers talk of their profession, musicians sing, artists and painters draw, philosophers discuss questions of nature, and poets recite their own and other people's verses."

Was it any wonder that Ludovico was dragging his heels on his way to the altar? Nothing could be done about his pledge to enter what had been planned as a major dynastic alliance with Beatrice and her family, so Ludovico did what he could to delay it for as long as possible. He pleaded in excuse his many activities. One in particular he failed to mention was getting Cecilia pregnant.

Lady with an Ermine might or might not have been painted at the time Cecilia was carrying Ludovico's child, but there is no arguing the fact that the portrait had been commissioned to celebrate Ludovico's intimate relationship with her, and that the ermine she cradles comes with symbolic associations in an allegorical allusion to him, who, having been invested of the Neapolitan Order of the Ermine, sometimes went by the name of Ermellino Bianco, or *White Ermine*. It has also been pointed out that ermine in ancient Greek is called *galé* (γαλή), referring possibly to Cecilia's family name, Gallerani.

The meaning of the animal remains a mystery. Rare,

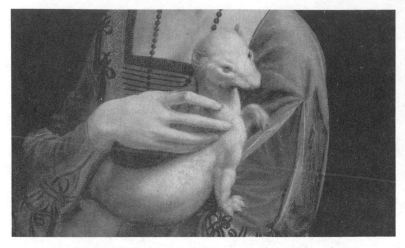

Cecilia's hand holds the subdued ermine, an animal with a reputation as a ruthless killer of prey many times its own size. Her gentle control of it might suggest that she has tamed her lover, Sforza.

even today, is any reference to the ermine in the portrait, though it was the visual inspiration for Philip Pullman's conception of demons that features in his fantasy trilogy, *His Dark Materials*. Pullman envisioned a demon to be an external manifestation of a person's inner self as a physically embodied spirit animal, endowed with human intelligence, capable of human speech, and often the opposite sex of the character it accompanies.

The recent application of highly sensitive scanning and imaging technology makes it possible to view layers of painting and underpainting by tracing the carbon beneath each layer. Leonardo was known for revising, editing, and reinventing his paintings, so it comes as no surprise that *Lady with an Ermine* has a far more complex history than

was previously thought. Conservationists who are technologically capable of peeling back the portrait's layers that encompass all steps of the composition have discovered that the portrait was painted in not one but three stages.

The first version was a portrait of only Cecilia. The ermine was added in the second version, and according to the imaging its fur was originally gray before Leonardo changed it to white, a symbol of purity. (It was believed that the animal would let itself be captured rather than defiling its pristine white fur and that hunters placed muck around its lair, counting on the likelihood that it wouldn't sully itself even by retreating to safety.) In the third and final version, the creature has been transformed into a larger, muscular animal with the paws of a lion—presumably to represent Ludovico's prowess.

If the ermine is a political allegory representing Ludovico cradled in Cecilia's arms, then the depiction that Leonardo created in the portrait presents itself as a double entendre: the ermine represents Ludovico, and at the same time it represents Cecilia, whose lithe body mirrors not only the shape of the ermine she envelops but also its shared longings.

Whether Leonardo decided to add the ermine or Cecilia asked him to alter the animal as well as the color of its fur in order to leave little doubt about her intimate relationship with Ludovico, it was becoming obvious that his reluctance to give her up was threatening what had been the carefully planned alliance between the d'Este and the Sforza families. Having successfully steered the well-trodden routes through the societal expectations

of women who, like herself, had husbands they did not choose but who had been dropped upon them, Ludovico's future mother-in-law, Eleanora, understood such things. After becoming aware of *Lady with an Ermine*—and, by extension, the reason for Ludovico's delay in marrying her daughter—she advised Beatrice not to allow despair the upper hand.

"Time cannot be forced" was her pragmatic view, conveyed in a letter to her daughter. "The less importance is attached to Cecilia, the more quickly will Ludovico relinquish her."

Time did play a part, but not in the way Beatrice hoped. It was with the purpose of buying more time that Ludovico instructed his lawyers to generate an overly complicated marriage document. Beatrice was stuck in limbo. Aware that he was impudently attached to another woman but hoping to prevent a diplomatic disaster, Ludovico dispatched an emissary to deliver a make-good to his future wife: a string of valuable pearls set in gold and embellished with an impressively large emerald. The gift was a major statement but fell short in proof of lasting intentions, and with no backdoor alternative Ludovico was forced to swear solemnly in front of ambassadors not to infringe the conjugal vows. This was ambassadorial dictation for "something has to be done about Cecilia."

———

It was assumed that the matter of Cecilia was finally resolved when, in 1491, a court astrologer selected the propitious day for Ludovico's marriage. In a public display of pageantry, trumpeters led the way through streets ban-

nered with the Sforza colors as fifteen-year-old Beatrice entered Milan to marry thirty-eight-year-old Ludovico. Making for a shaky start to the marriage was what she discovered shortly after her wedding trousseau was unpacked: Ludovico's enchantress, Cecilia, had remained on the premises, and *Lady with an Ermine* still hung on a wall in the *castello*'s private apartments.

Ludovico provided further evidence of this behavioral trait when he continued to house Cecilia and the son she had by him in the same walled confines as his newly minted wife.

Illegitimate children of dukes were untainted by their circumstances, and so the birth of Cecilia's son by Ludovico was not hidden. Though hereditary reasons prevented the legitimization of the infant, he was named Cesare and deeded with property. When Beatrice discovered that she would be sharing living quarters with Cecilia and Cesare, she also learned that both were being openly celebrated by the court poets who composed sonnets in their honor.

Faced with the indignity of her situation, Beatrice utilized one of the few options available to her—calculated power dressing. She signaled her important standing in court by draping herself in voluminous gowns with sweeping floor-length sleeves. She then weaponized couture: fabric sheen was an indication of prestige, and Beatrice decreed that Cecilia was forbidden to wear any dress featuring the slightest display of embroidered gold brocade. Nothing, it seemed, prevented resentment from seeping through Beatrice's one-of-a-kind gowns, and she demanded that Cecilia and Cesare leave the *castello*.

Because the presence of a duke's mistress and any of his

illegitimate offspring were common in Italian courts, Beatrice's staunchly expressed stand was considered naive. In bruised defiance, she held her ground. The loss was bravely borne by Cecilia, who exercised a dignified strength. For his part, Ludovico bestowed respectability upon her with an arranged marriage to the amenable count Carminati de' Brambilla. He deeded them both with the Carmagnola Palace, whose original structure was built by a Visconti, and then supervised its renovation with Leonardo participating to a degree in its embellishment. Either as a personal gift or tucked under her arm when departing the ducal household, *Lady with an Ermine* came into Cecilia's possession. Less certain is what happened to it next.

EIGHT

WITH CECILIA GONE, Beatrice finally let go of resentment. There was another change, this one wholly unexpected. She became interested in sex. Ludovico didn't turn down the additional dividend of sexual recreation made unremittable by his wife. No surprise there. What was surprising, even to Ludovico, was his growing attachment to her in a fuller sense. Beatrice's energetic and passionate childishness and absurdities, her mirthful candor in likes and dislikes, all of this appealed to him.

Each passing day brought Beatrice a calm certainty of marital stability, and her hard-won contentment was fortified by the tightly knit d'Este family. She was especially close to her sister, Isabella, who was a year older and had been pledged to Francesco Gonzaga, the heir to the Marquess of Mantua, a title he inherited by the time the wedding took place ten years later. For any other woman, a marriage of this magnitude would have been enough, but Isabella was not any other woman, and she would become one of the most vivid personalities of the Italian Renaissance.

Without losing sight of what was expected of her in a time that was unreceptive to unambiguously dominant women—even those of nobility—Isabella exerted no obvious force for the influence to which she aspired. To cultivate a public image, she first established a reputation as a fashion trendsetter—one who designed hats and created fetching hairstyles. Shoes, especially, were the subject of her attention: for the women with no intention of placing a foot on the ground, there were embroidered slippers; for those willing but not necessarily eager to venture outdoors, Isabella devised a type of shoe with heels high enough to prevent the rim of a dress from getting dirty. When the notoriously snobby French court—with its hyperbolic fashion trends—began copying Isabella's innovative style, she executed a tactical pivot by realigning her focus on Lombardy's artists and intellectuals and presented herself as a patron with a wide range of cultural interests. The next phase to Isabella's carefully calculated campaign of self-promotion entailed fortifying her position within the social and political framework of Mantua. She began by overseeing organized events at which she staged her appearances with great care.

If Isabella lived today, she would have been deemed a social influencer, successful in persuading others to take her at her own formidable estimation. Putting to work her innate understanding of how to use image as a branding tool, she commissioned a commemorative coin of herself that, when widely distributed, created a burnished impression among those she wished to impress or whose loyalty she sought to preserve.

Portraits on Renaissance commemorative coins were meant to illustrate the subject's exemplary characteristics, whether or not those qualities existed. Isabella's coin featured a portrayal of her own precise dictation. In no sense was it an accurate likeness: while the Isabella reflected in a mirror had a long nose, a dominant chin with early signs of doubling, and slightly protruding eyes, the Isabella on the coin had an evenly featured face, coiffed hair, and the appearance of more years than she actually possessed. Drawing attention to the huge pearl necklace she was wearing was her audaciously posed profile facing right—just as a man's would—making visually clear the authority by which she carried her head. Isabella's game face was on, and from its expression it's easy to believe that she was probably not patient with fools or, for that matter, very good with children. As for men, she treated them as though they were something to be managed. It wasn't as though she didn't like men; she liked them very much, especially in the ways they are different from women. But,

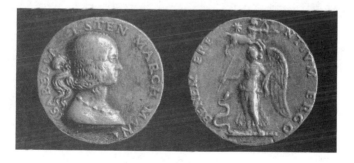

Isabella controlled her own narrative with a commemorative coin:
its reverse side featured a winged Victory beneath the sign of Sagittarius
and a star, symbolizing her birth under auspicious circumstances.

as a well-educated person, she had a difficult time accepting the legitimacy of men's authority when history confirmed that they hadn't been entirely successful in managing civilization. Nothing she experienced later in her life would contradict this view.

Living in circumstances that dictated her essential purpose to be marriage and giving birth to a son, Isabella perfected the limited means that would enable her to advance in a world whose bias had already been written into her life. The tools she used didn't stop with commemorative coins: she commissioned painted portraits of herself that were sent to those she identified as relevant or possibly helpful in the courts that dotted the Italian peninsula.

Married to a largely absent prince fighting to protect his domain—and with enough unflagging drive to power the entirety of Mantua—Isabella made a point of sustaining her husband's network with her own correspondence. Italy's city-states housed a complex colony of intermarriages among the ruling nobility, and her continual contact with marital relations and their couriers gave the appearance of her interest in their domestic affairs, when, all the while, she was gathering information on broader issues. With more than sixteen thousand letters written and some nine thousand received, she knew instinctively what type of communication to compose, to whom, and when to send it.

Someone with whom Isabella had the most reason to remain in touch was Beatrice. Having more in common than that which might have separated them after they were married, the sisters had remained on good terms—so much

so that Beatrice instructed that a field of garlic be planted in Milan to season her sister's favorite dishes in time for her first visit there. When Isabella made that much-anticipated trip, she had a close look at Beatrice's luxurious circumstances at a time when her own funds in Mantua could be found in a sustained state of fluctuation. From Milan, Isabella wrote to her husband, Francesco, "Would to God that we, who love spending, had as much."

One thing led to another and culminated when the garlic-seasoned feasts placed in front of Isabella became secondary to the sharp craving she had for the man seated at the head of the table—her brother-in-law, Ludovico. Whether their mutual attraction included a sexual component is open to debate, but it was maintained with weekly correspondence shuttling between Milan and Mantua in the hands of a trusted courier. Ludovico's letters, while invigorating for Isabella to expect, once read, had a tendency to irritate her, especially those that included jealousy-inducing details. Isabella was galled to learn, for example, that her sister did not shy away from a full set of jewelry in the daytime and, when traveling, was accompanied by attendants on horses tacked with gold-embroidered velvet and adorned with semiprecious stones. Eventually, any mention of Beatrice's privileges became a trip wire for Isabella's resentment.

With no interest in understanding the difference between desire and viability—and believing that beautiful things should go to those who can appreciate them best—Isabella couldn't help compare her circumstances with those of Beatrice. Ludovico's reports of the free-floating

diversions in his court featuring Beatrice at its center forced Isabella to revisit what she considered a profound injustice: that, had she not been previously promised to Francesco when Ludovico approached her father with a betrothal offer, it would have been she, not Beatrice, who became the cynosure of Milan.

NINE

EACH PASSING DAY Beatrice enjoyed marital stability induced in her an unwitting expectation that Ludovico was providing something that he wasn't—fidelity. Other than what had been an unalloyed love for Cecilia, he had never been devoted to one woman. Ludovico would have assumed that Beatrice was aware of this, but if on the off chance he felt obliged to justify himself, no doubt he would have suggested that his unfaithfulness wasn't a lack of character on his part so much as his distaste for Beatrice's emotional neediness.

The Milanese court provided a surround sound of sex. According to the courtier Matteo Bandello, "Husbands and wives were in the same category as highway cutthroats and bandits." Ludovico need not have looked very far for a mistress: Lucrezia Crivelli was Beatrice's exceptionally attractive lady-in-waiting.

Marital fidelity had been the text prepared for Lucrezia before she was married, but she decided that there was no point in taking it seriously when a successful affair with

Ludovico promised to bring life-changing riches for herself and her morally elastic husband. Her family, too, shared in the spoils. Her brother, a priest, was quick to leverage Lucrezia's relationship with the duke for church appointments that came with optimal property and income.

Initially, Ludovico didn't flaunt his affair in front of Beatrice. That effort was abandoned when he found discretion too depleting and decided to commission Leonardo to paint Lucrezia's portrait, so it was rumored. *La Belle Ferronnière* takes its name from the *ferronnière* the sitter wears around her brow, a common Lombard fashion, which had made an appearance in *Lady with an Ermine*. Also known as *Portrait of an Unknown Woman,* the picture poses more questions than it answers—including whether Leonardo actually painted it. With the exception of *Lady with an Ermine,* Leonardo's participation in his portraits of women was known to be erratic, and with some it was thought that they were workshop products, so to speak—that he composed a drawing of the subject and left the painting of it to his assistants. A number of prominent art historians point out that the woman's features in *La Belle Ferronnière* are heavier than those normally found in Leonardo's other portraits. They have floated the idea that the picture might have been based on Leonardo's design but executed by one or several of his apprentices. Regardless of its full and accurate attribution, if it were a portrait of Lucrezia, it would have been commissioned by Ludovico when she was his mistress. The impressive-sized amethyst centered on her forehead resembles more a hard stamp of experience than a gem. That—along with her exfoliating

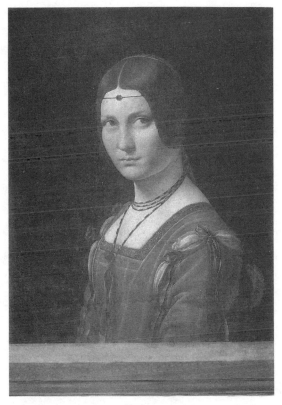

*In what may or may not be an entirely Leonardo portrait,
Lucrezia might or might not have been the woman capable of burning holes
with her unflinching stare.*

expression—suggests that she was extremely capable of taking care of herself.

Because she was made desperately unhappy after being sidelined by Lucrezia, Beatrice's mental health began to unravel when she discovered that they were both pregnant by Ludovico. Tormented by defeat and unendurable

resentment, with very little comfort to be had, Beatrice found a self-numbing relief in sex orgies—sex being the one thing she could do without thinking about anything else while doing it. Whether a coping mechanism or the blind compulsion to punish herself for the pain caused to her by others, sex became her own frenzied current of self-harm, and she collapsed during a woozy all-nighter. Unable to distinguish between her desperate gasps to breathe and what they assumed were the sounds of lust, the musicians continued to play. Beatrice gave birth prematurely to a stillborn baby boy the next morning and died a few hours later, inconsolable and not yet having reached the age of twenty-two.

Regret wasn't Ludovico's strong suit, but seeing his young deceased wife lying side by side with her dead baby forced him to confront his own mortality. He commissioned the design of a holy mausoleum to include a panoramic scene on one of the walls in the refectory of the monastery of Santa Maria delle Grazie. Delaying the project was, predictably, Leonardo, who had an ongoing search in Milan's jails for a villain to pose as Judas, one of thirteen characters in his conception of the large mural. There was also the unresolved issue of the choice of paint type. Because the proven method of fresco painting would have left him no allowance to modify his work, Leonardo decided to use an experimental tempera technique based on thin, transparent oil glazes and—as it turned out— one that was incompatible with the damp cloister wall. Its mournful outcome is history's record: hardly finished, *The Last Supper* began to flake.

Beatrice died in a time when the city-states were refusing to acknowledge the impending disaster from Europe's major powers vying for a share of Italy's resources. Ludovico's destiny would play out as Italy entered a reign of bloody battles fought by foreign invaders. None of this impeded Isabella's own unstoppable advance. Churning through life much like a warship cuts through unsettled waters, she continued to seek and acquire the things she wanted.

Lacking cash flow but possessing the adroitness of a self-taught expert and the feminine charm of a woman well practiced in that discipline, Isabella became one of the most successful art collectors in what was a man's arena. It made no difference that she was unable to pay the going rates for the great works or to commission well-known artists. As an obstinate bargain hunter with a razor-sharp awareness of human weaknesses, she would send a delegate to a particular artist on whom she had set her sights with instructions to leave a modest sum behind. By the time the delegate returned to Mantua, the artist would have spent the money and created an obligation. Nothing on which Isabella set her mind was forgotten by her, nor did she allow others to forget. In dogged pursuit, she would nudge, coerce, and pressure week after week, month after month—sometimes, year after year—with inexhaustible correspondence reminding the unwitting artist what was expected of him, and reduced to obedience, he would discharge his obligation.

Failing to obtain a picture from Leonardo and recog-

nizing that—in his case—her ploy of snaring with debt would be ineffective, Isabella did what she did exceptionally well: she wrote a letter. This one was to Cecilia, who, after the death of her husband and that of one of her sons, retired to her husband's Lombardy estate at San Giovanni in Croce. In her letter, Isabella's request was couched in civility but not entirely subtle: she wanted to borrow *Lady with an Ermine*.

"Having seen today some fine portraits by the hand of Giovanni Bellini, we began to discuss the works of Leonardo," Isabella wrote. "And since we remember that he painted your likeness, we beg you to be so good as to send us your portrait by this messenger that we have dispatched on horseback, so that we may not only be able to compare the works of the two masters, but also have the pleasure of seeing your face again."

Uncommonly wise at the age of twenty-five, Cecilia must have known that Leonardo's portrait of her was a teasing reminder that she had taken a sure-footed path away from what was once captivatingly youthful beauty. Complying with Isabella's request reluctantly, Cecilia handed *Lady with an Ermine* to the waiting horse messenger who placed it in his saddlebag. She gave him a note to deliver to Isabella. In a tone of fatalism that was untinged by any bitterness, it read, "I have seen what your Excellency wrote to me about wishing to see my portrait, which I am sending to you. I should send it more readily if it resembled me more. Do not, your Excellency, attribute this to a defect on the part of the master, because in truth I think there is none to be found who equals him; rather

it is merely that the portrait was done when I was at an immature age. Since then, I have changed so much from that likeness that to see it and me together, no one would judge that it had been made of me."

The year Cecilia sent *Lady with an Ermine* to Isabella, Milan was entering a high-stakes turf war with other European nations. Playing his enemies against each other in a complicated series of political intrigues, Ludovico proved just how hapless a politician he was when he enlisted France's future king Louis of Orléans in the hopes of persuading him to become an ally. The ill-conceived invitation provided Louis with a firsthand look at Milan's lack of defense, and shortly after the crown was placed on his head, he crossed the Alps with his army and claimed the Milanese title for himself.

Contributing to Ludovico's downfall were his blinkered assumptions about the mood of his citizens. After years of being thrown the scraps of Ludovico's largesse, when the time came for the Milanese to show him their loyalty, instead they welcomed the French king Louis XII with enthusiasm—so much so that he conquered their city in the short space of twenty days. He also claimed Ludovico's much-loved *castello*, which set right the injustice suffered by his grandmother decades before. She was a Visconti by birth and, as a young girl, had been thrown off that same fortified plot of land by Ludovico's father.

In a finale that could scarcely seem more meaningful, the viper-bitten blood prevailed.

"THE DUKE HAS LOST HIS STATE and its possessions, and his possessions and his liberty."

After an eighteen-year association, this was Leonardo's brief and coldly lucid report of Ludovico's demise at the hands of the French.

Italian families of military nobility faced the unavoidable choice of where to direct their alliance, and when the French ambassador suggested that Isabella was "pro-Sforza," she was quick to express a combination of indignation and hurt in a letter to him, insisting she was "as good a Frenchwoman as any could be." So convincing was her protestation that the ambassador offered profuse apologies for his "mistaken idea."

Because she sought and enjoyed the material things in life, it is perhaps not totally surprising that Isabella placated the French occupying her country with gestures of friendship, going so far as to single out Cecilia to King Louis XII, recommending her as a "lady of true gifts and charms." A procurement? It might have been. Isabella had

a transactional approach to virtually everything. By currying enough favor with the French, she was able to appropriate certain collectibles from Ludovico's *castello,* though this did little to divert her most ardent desire—one that only continued to sharpen: a painted portrait of her by Leonardo.

Isabella had hoped that Leonardo's sketch of her, most probably done in 1500, would be a precursor to his painted portrait.

After years of casting every conceivable net in Leonardo's path—and with her own best interests firmly in view—Isabella thought that she finally had something of value to offer him after France's irruption on Italian soil: a safe haven for him in Mantua. And when Leonardo accepted her offer, she allowed herself to believe that her years of maneuvering had finally paid off. That would have been a logical conclusion, but what is logical is not always correct, and despite Isabella's redoubled zeal she hadn't taken into account that, like her, Leonardo cared primarily for himself. He cooperated, but only up to the point of completing a charcoal drawing of her.

Leonardo's drawing of Isabella is a depiction of a woman with an impervious core and solemn importance, but not of one with whom you would fall in love. Despite the warm tones of red chalk and yellow ocher, he reduced her fully fleshed face to the fundamentals of her true nature: civility and perseverance. Just so, for what started as Isabella's complimentary politeness with Leonardo became a sawing insistence that he take the next step and paint her portrait. He did not, nor would he. In his restless moving to and fro, Mantua was but a short stop on his way to Venice.

Isabella's disappointment in failing to persuade Leonardo to paint her paled against the political events of the time: Italy was becoming a battleground for European supremacy, with foreign invasions launched from France, the Holy Roman Empire, Spain, England, and the Ottoman Empire. Facing defeat, Ludovico retreated to the German forests, taking with him treasures to pay Swiss

mercenaries he hired to recapture Milan. Nothing about this combination of circumstances suggested a successful ending. Ludovico had failed to consider what would happen when his cache of treasures had been exhausted. The mercenaries handed him over to the French army for a fee; it had been deadly stupid to expect anything less. Ludovico endured ten years of brutal incarceration in France before expiring in one of its prisons.

That same decade saw Leonardo move from one city-state to another. Having left wounded, smoke-soiled Milan for Mantua, he departed Mantua for Venice, only to find Venice under threat from Turks.

Plunging into scientific research, Leonardo concentrated his investigations on hydraulics. One of his proposals was to sink the Turkish fleet using divers equipped with underwater breathing apparatus. When the idea was judged unworkable, Leonardo left Venice.

His travels had brought him full circle to Florence—the city from which he departed eighteen years earlier to join Ludovico's court in Milan. Aged forty-eight, Leonardo was determined to pursue his interests without the numbingly consistent need to earn money. That opportunity was offered by Cesare Borgia, whose ice-cold singleness of purpose inspired Machiavelli's *Prince*.

By the time Cesare Borgia reached his mid-twenties, his career had already become a revolving door of crime. To what degree his bad-to-the-bone villainy had calcified is not known. Suffice it to say that when he was introduced to Leonardo in Venice, he was demanding more innovative ways to kill his enemies.

Cesare Borgia, the illegitimate son of Pope Alexander VI, had a reputation for stop-at-nothing cruelty. No charge could be more merited.

One might have thought that Leonardo—to whom the more brutal aspects of war remained anathema—would not have been disposed to put himself at the service of someone so ruthless. The multifaceted truth was that Leonardo was just as capable of imagining explosive aster-oids that would kill with sharp slivers of slaughter as he was of creating some of mankind's most compelling reli-

gious images. Power, politics, and ideology had no effect on Leonardo. He was responsible for breathtaking beauty, but in what some would suggest was a rolling Faustian pact, he also concentrated his imagination on horrific inventions of death on behalf of his patrons without ever embarking on his own discovery of moral reasoning.

—————

After the fall of the Borgia dynasty in Venice, Leonardo circled back to Florence to find that it, too, had been confronted by an enemy; this time, it was Pisa. The political mastermind Niccolò Machiavelli had met Leonardo while previously visiting the court of Cesare Borgia. Having established a position of power within the Florentine court, Machiavelli hatched a scheme with the hydraulically savvy Leonardo that he was confident would enrich Florence and, at the same time, defeat Pisa. Their plan was to reroute the Arno River, the main water source for both cities: diverting the river into a series of canals that would simultaneously cut the water supply to Pisa and make it possible for ships to sail from Florence to the Mediterranean.

The caper failed to take hold, and in 1525, Leonardo trailed back to Milan, where Italian forces were still warring with the French. Watching the deadly conflict unfold with the kind of detachment that came so easily to him, Leonardo sketched the battles' flames, noting the air movement caused by the heat from such a disastrous conflagration.

For too many years, Leonardo had placed his service with the clashing vassals of princes and dukes, all of whom

enlisted him at some point with the purpose of advancing their military capabilities. He left Milan tired of war, and with an invitation from the papal court he went to Rome, a city of splendor and squalor in equal measure, where wooden hutches of the poor hovered around a Vatican decorated with elaborate frescoes.

Leonardo's three years in Rome enabled him to pursue his interest in the field of architecture, which, famously, resulted in an ink-on-paper drawing depicting a man— arms and legs spread apart and inscribed in both a circle and a square. His *Vitruvian Man* represents the ideal human proportions and its correlation with geometry based on journal entries of the ancient Roman architect Vitruvius from the first century BC.

The papal court presented unique opportunities along with challenges, one being that the pope forbade Leonardo to conduct autopsies. There was also the personal issue of hygiene. Clean by habit, Leonardo found it difficult to be within proximity to the pope, whose swollen stomach and congested complexion were the repellent results of his overindulgence with food.

Recognizing that the court was increasingly training its admiration on a more youthful artist, Raphael, and suffering from what he considered forced inaction, Leonardo made up his mind to leave Rome. The question of where he would go was resolved when France's new king, François I—with troops in tow—crossed the Alps and recaptured Lombardy. The king, who had visited the refectory of Santa Maria delle Grazie in Milan to see *The Last Supper,* propositioned Leonardo.

"As I am unable to take away with me your masterpiece, I intend to take away the painter," he told him.

What else need be said?

Being bestowed the rank of First Painter, Engineer, and Architect of the King could not have been more appreciated by Leonardo. His life as an artist had been out of his control for so many years: siege after siege, upheaval upon upheaval, treachery upon treachery—all of these draining circumstances had been forced on him, often by men he didn't admire. He longed for the uninterrupted time to pursue labor to his liking. Now, finally, he was granted the certitude of an un-begrudged, undisputed place to make this happen.

When, in 1515, Leonardo left the country of his birth for the first time, he was suffering from several physical ailments. His body was beginning to fail him. Holding on to the reins of his horse while traveling north toward France, his right hand quivered uncontrollably. In two years, it would be completely paralyzed.

Leonardo's last journey ended in the town of Amboise in France's Loire Valley. The king's court would not be as brilliant as the others he had experienced, but it placed at his disposal Le Cloux, the residence that had belonged to the queen mother and was within proximity to the king's summer residence. That airy, sunlit house—along with a generous pension—provided Leonardo with a long-deserved independence and hard-won sense of place.

An unfinished picture he brought with him was his

portrait of a Florentine woman, commissioned by her considerably older and twice-widowed husband, a rich merchant. Having devoted four years of work to the portrait, Leonardo insisted that it was not yet finished, though it's been suggested that he was allowed to keep the portrait in a state of perpetual progress because the expression he'd given the woman in her portrait was one no husband could have long endured. Her immutable smile—which would be revised many times over—was seen by few other than the French king, who, eventually, would purchase what came to be known as the *Mona Lisa* for himself.

During Leonardo's last fulfilling years in France, Italian forces managed to overtake the French in Milan and reinstate the Sforza family to power and into the hands of Ludovico's son Massimiliano. Six years later, the Italians lost Milan again to Spain, and under Spanish protection Francesco II, the brother of Massimiliano, became the new Duke of Milan. All told, only eighty-five years elapsed between the day Francesco I Sforza made himself master of Milan and that on which his grandson and namesake died childless. With the death of Francesco II in 1535, and no legitimate heirs, Milan fell under the rule of Charles V of Spain. The Sforza Castle, once a lordly residence, became an army barracks—a function it would continue to retain during the many assorted foreign dominations of Milan.

That Cecilia died in 1536 is a matter of recorded history, but there is no record of what happened to *Lady*

with an Ermine after she agreed to send it to Isabella some thirty-six years prior. Having met Leonardo during her early introduction to the Milanese court, Isabella realized his importance sooner—and, perhaps, more—than Ludovico. Her innate understanding of contemporary artistic achievements gives weight to the possibility that rather than returning *Lady with an Ermine* to Cecilia, she might have decided to hold on to it.

Isabella was a cocktail mix of brilliance, ingenuity, and perseverance. Above all, she was determined to have a painting by Leonardo. No one can argue any of this, but the fact that her collection was too well known for a Leonardo picture not to have been recorded or mentioned backs us into the assumption that Isabella returned Cecilia's portrait to her.

Though the next two and a half centuries would not volunteer anything concrete on the whereabouts of *Lady with an Ermine,* an unrecorded journey is a journey nonetheless.

PART TWO

The portrait's missing years;

its next recorded owner, a Polish princess

who was a cross between

feminine charm and dynamite.

ELEVEN

WITH THEIR STUBBORN ALLEGIANCE to facts, art historians have been trained to stay in a narrow and straight lane of investigation with clear evidence leading the way, and so their discomfort is understandable when a picture disappears from the records.

"Lost to view" is the dignified expression assigned to the over 250 mysterious years that *Lady with an Ermine* vanished without a trace. With no unequivocal evidence to explain what happened to the picture, only by wandering onto the weedy path of conjecture would one come across a sixteenth-century Italian scholar by the name of Giulio Cesare della Scala who claimed to have seen *Lady with an Ermine* while attending one of Cecilia's salons at some point between 1514 and 1515 in San Giovanni in Croce.

Those years coincide with Cecilia's residency in Croce when her salons in San Giovanni became a well-known watering hole for intellectuals. This time-based fact was enough to send a hopeful researcher to seek archival con-

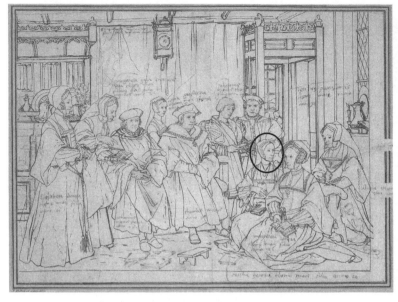

Look carefully at the young woman, third from the right: she is Thomas More's youngest daughter, Cicely—Cecilia by any other name.

firmation first in Lombardy and next in Milan and Mantua. Though the records revealed that Cecilia's niece and heir, Camilla de Predis, married into a wealthy family from Milan, there was no indication that the portrait remained in the hands of her family.

Another hypothetical scenario of *Lady with an Ermine*'s missing years might have to do with Cecilia's pose. It was common practice for young painters to learn to draw by copying prints or pictures by the great masters. Leonardo was more than a master: he was a pan-European celebrity who had been elevated to something akin to icon status. Given that the circulation of engravings played a role in

the dissemination of iconography, why was *Lady with an Ermine* never copied by other artists or—for that matter—recopied by imitators? And how had the unique *contrapposto* pose Leonardo gave Cecilia (suddenly turning to the left as if her attention were caught by an impromptu appearance of someone beyond our scope of vision) found its way to English shores in the depiction of another Cecilia featured in Hans Holbein's 1527 preparatory study for a group portrait of Sir Thomas More's family?

According to Giulio's anecdotal evidence, *Lady with an Ermine* was hanging in Cecilia's residence while Holbein was in Italy (1517–19). The dates coincide, and though an intriguing prospect, it would take a conceptual leap to place Holbein in front of Leonardo's portrait of Cecilia. A more prudent course would be to assign sheer coincidence to the fact that the two women shared both a given name and the distinctive pose.

Another theory places the picture with Rudolf II Habsburg, the king of Hungary and Bohemia and Holy Roman emperor in the 1580s. Despite his full-tilt eccentricities, Rudolf II raised court patronage in post-Renaissance Europe to a punchy new level, and for those who found transgressive behavior seductive, it would have been difficult to resist a man thrilled by his official image composed exclusively of flowers, fruits, and vegetables.

In addition to Rudolf's princely *Kunstkammer* (a cabinet of curiosities) that featured a jamboree of precious rarities on a hitherto unknown scale, his collection of pictures numbered in the thousands. Many were Italian. Listed in his 1621 inventory are two paintings by Leonardo, one

Rudolf II could not have been more delighted with his loony portrait
by Giuseppe Arcimboldo (1590–91).

titled *A Woman with a Small Dog*. Was this *Lady with an Ermine*? Not to be overlooked is the fact that some 260 years later a catalog reference of the proven *Lady with an Ermine* would also mistake the ermine for "an ugly dog." Despite this cross-reference, the question of whether Rudolf owned the portrait must be left unanswered, for, though he considered himself a prize to bestow on both

sexes, he never wed, and when he died in 1612, his art collection was largely dispersed.

The various rumors of *Lady with an Ermine*'s provenance are tempting to consider, but it seems more likely that the portrait remained in an undisclosed place—or, for that matter, places—in Italy for decades. One person who clung to that belief was the scholar and encyclopedist Carlo Amoretti. Born in northern Italy in 1741, Amoretti developed extraordinary expertise in history, theology, paleography, physics, geography, and geology. His fierce intelligence must have had a rebellious streak, for, not long after entering the Order of Saint Augustine, he fell from its grace. After relocating to Milan, Amoretti became the editor of the first published scientific magazine and the conservator of Biblioteca Ambrosiana (the Ambrosian Library), thought to be the first public library in Europe, where he transcribed, edited, and annotated manuscripts. In one, he wrote that *Lady with an Ermine* "was still to be seen in Milan, in the collection of the Marquises of Bonasanna."

A contemporary of Amoretti's was a man burdened with the run-on name Cesare Bonesanna di Beccaria, Marquis of Gualdrasco and Villareggio. In his capacity as both politician and philosopher, he had a profound influence on America's Founding Fathers through his writings on criminal law and justice. Born in Milan, he hailed from an aristocratic family that had lived in a condition Amoretti described as "moderate well-being." If "moderate" constituted the financial means to have acquired *Lady with an Ermine,* it would make sense that the picture was inher-

ited by Cesare Bonesanna di Beccaria and that it remained with him for a period of time. But this, too, would be speculation.

The only definitive thing one can say about the extended time that *Lady with an Ermine* remained lost to view is how remarkable it is that it survived at all, for, during this same period, Italy was being pulled apart from a sequence of disastrous alliances. Charles V of Spain would abdicate in favor of his son Philip II; Milan would remain with the Spanish line of the Habsburgs; the death of Philip II would extinguish the Spanish line of the Habsburgs; French troops would back the claim of France's Philippe of Anjou to the Spanish throne, after which they would be forced to yield northern Italy to the Austrian Habsburgs.

For more than two centuries—when not suffering from political conflicts, peasant revolts, and the Inquisition— Europe lurched from one dynastic or religious war to the next. While Providence did its very best to safeguard *Lady with an Ermine,* when needed, it fell to a series of spirited women to rescue it.

The first was an unconventional Polish princess.

TWELVE

PRINCESS IZABELA DOROTA CZARTORYSKA was born in 1746, when Poland was still one of the greatest empires in Europe. She was the only child of parents whose family dynasties had been cushioned by hundreds of years of wealth and privilege.

Her father was the grand treasurer of the Duchy of Lithuania, which, in the fourteenth century, had entered into a partnership with Poland; her mother was a Czartoryska—the Czartoryskis being an ancient Polish-Lithuanian dynasty. The combined real estate holdings from their union included vast estates in Poland's capital, Warsaw; Sieniawa, in southeast Poland; and Pulawy, located in eastern Poland.

Izabela's mother died at twenty-two giving birth to her. When her father remarried, it was to her mother's sister. In a strange twist of fate, her stepmother also died in childbirth at the same age as Izabela's mother.

In order to continue the combined fortunes of the two families, Izabela became engaged to her mother's cousin Prince Adam Kazimierz Czartoryski. That he was

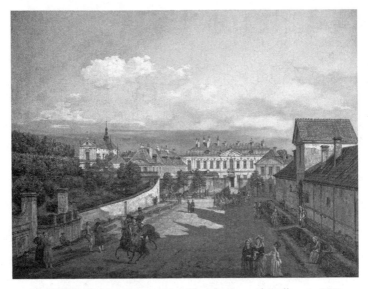

The Blue Palace in Warsaw, painted here by Bernardo Bellotto in 1779, was one of three grand Polish estates owned by the Czartoryskis.

more than twice her age was mitigated by Izabela's self-assuredness, which introduced itself immediately at the altar: having contracted smallpox not long before the wedding, she had a veil made with a less transparent weave rather than postponing the ceremony until the sores on her face had healed.

Anglicized as a result of an English education, Prince Czartoryski was an enlightened man with a wizardly gift for languages, a devotion to studies in history, art, science, and political economy, and the habit of hiring Jesuits as secretaries. More mentor to his young bride than husband, he chose as their honeymoon a grand tour.

The grand tour was a regular feature in an aristocrat's

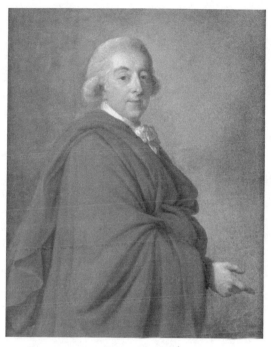

Prince Adam Kazimierz Czartoryski, by Élisabeth Vigée Le Brun,
a prominent and peripatetic French portrait painter.

education, but what made this one unusual was, through-
out it, Izabela wore the uniform of her husband's regiment
and passed herself off as a young man. Requiring a struggle
to thread the needle of probability is the suggestion that
because they were traveling by horse-drawn carriages, the
ruse provided Izabela a certain freedom of movement and
the couple with a spontaneity in arrivals and departures
from one place to another. Regardless of the reason, the
fact of it allows us at least two conclusions: Izabela's hus-
band must have been comfortable with the masquerade;

*Omitted in Izabela's formal portrait by Alexander Roslin
are the smallpox scars that marred her face.*

and Izabela must have been androgynous looking enough
to pass convincingly as a young man. Indeed, staying in
male guise while in Frankfurt, she was mistaken for a Dan-
ish prince who happened also to be in town.

Years later, Izabela wrote a frank critique of her physi-
cal self: "I have never been beautiful, but I have often
been pretty. I have beautiful eyes and, as all my feelings
are reflected in them, the expression on my face is often
interesting. My complexion is white enough to be almost
brilliant when I blush. My forehead is smooth, my nose is
neither ugly nor beautiful, my mouth is large, my teeth are
white, my smile is amiable. I have enough hair to decorate
my head with it, and it is dark, like my eyebrows. I am
rather tall, my figure is elegant, my bust perhaps too thin,

my hands are ugly, but my legs are lovely and graceful in movements."

To her blunt self-appraisal Izabela added, "My face resembles my mind—the greatest of both charms depends on the skill with which I can double their value. My defense is my tact. It never allows me to expose myself when I am not sure of victory."

According to one of her admirers, even the smallpox marks on her face added to her charm. When she smiled at men, it seemed to them like a reward, and she could direct it to half a dozen of them in a room during the course of as many minutes. Among her legions of admirers was Benjamin Franklin, who met her when they were both in London—she, during her extended grand tour, and he, during his futile endeavor to represent the American colonies there. So impressed was he with her that he arranged a private demonstration of his recent and—to be honest—fairly wacky invention: the glass harmonica. Made from thirty-seven glass bowls of varying thicknesses and sizes and threaded horizontally on an iron spindle, with the wet finger of the player, it could produce up to ten chords at a time.

There was a charm, as well, in the unabashed way Izabela wasn't in the least defensive about anything she did in her private life, which was never remotely private. Wielding sex like a flamethrower, she burned through one high-drama romance after another, and rather than agreeing to the game of make-believe, she refused to employ even a little deceit during numerous—sometimes simultaneous—extramarital affairs.

Disinclined to dwell very long on a single man, Izabela developed a proficiency at the practice of deadheading one lover in order for a replacement to grow. While some historians have suggested that there was a compulsive sexuality to her, others point out that several of her intimate associations were more in the line of "political affairs," a form of soft diplomacy encouraged by the Czartoryski family. The possible motivations behind Izabela's sexual exploits notwithstanding, they had little impact on her marital relationship, and it's easy to assume that she arrived early at an understanding with her accommodating husband, for the only child she had with him was followed quickly by another with her lover. That man was Stanislaw August Poniatowski, her husband's cousin, who, as it happened, had a previous relationship with one of her husband's sisters, who was Izabela's aunt.

Izabela's dalliance with Poniatowski occurred in a time when Poland was becoming increasingly alarmed by its neighboring countries. On one side of it was the Kingdom of Prussia, a military kingdom; on its other side was the Russian Empire, with its tradition of servility to the tsars. Unlike the absolutist states of Prussia and Russia, Poland's fluid government featured an elected king and a parliament of nobility, and the combination of the two prevented an absolute monarchy.

Describing Izabela's untethered sex life as complicated would not do it justice: it was a sexual carousel that featured alliances and family bonds, as well as animosities and rivalries. When she began her affair with Poniatowski, her husband had already been designated as the logical candi-

date for the next Polish king. The empress Catherine of Russia interceded by engineering Poniatowski's election to the crown rather than allowing it to go to Izabela's husband, in part because Catherine knew Poniatowski would be a more pliable instrument in Poland and because she had had an affair with him before he had one with Izabela.*

Izabela was a pragmatist whose shifting partnerships tacked to the political winds: still involved with Poniatowski, she began an affair with the Russian ambassador to Poland, Prince Nikolai Vasilyevich Repnin. That all three participants were married was not an issue. What caused concern amid this complexity was yet another complication: Izabela had a child—a daughter—by Poniatowski and continued her close associations with both men, unfazed that each resided on an opposite side of Poland's best interests.

Things worsened with Russia playing an ever-assertive role in Polish politics. Russia's ambassador in Poland, Prince Nikolai Vasilyevich Repnin, became Poland's de facto ruler, replacing the authority of the Polish king, Poniatowski.

There would be three partitions of Poland. The first, in 1772, saw Russia, Prussia, and Austria annex almost a third of Poland's territory, after which the Czartoryskis' holdings located within the Russian territories were appropriated. Despite the diminished state that Poland had become, Poniatowski made a valiant effort to press forward with reforms, but Russia had no intention of allowing a strong

* Poniatowski would be the last king of an independent Poland.

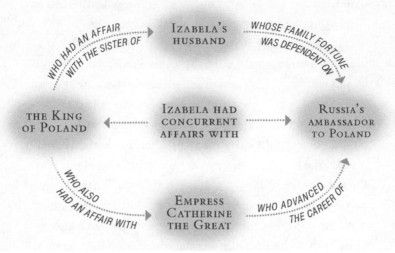

Given the elaborate web of mutual relationships,
things were bound to get sticky.

parliamentary democracy to emerge, and what followed
was a prolonged armed revolt.

Austria sat out Poland's second partition in 1793 while
factions split between Poland's king and Russia. The
Czartoryskis confronted the situation with more tenacity
than political savvy: they were willing to follow a policy
of friendship with Russia, but only if Poland were an equal
partner in matters having to do with its foreign policy. In
an epic failure to read the room, the Czartoryskis created
a disaster for themselves.

Never put off by obstacles, Izabela reviewed her playlist
of lovers before choosing one of them to come up with
a solution that would save the family's land and fortune.

"Prince Repnin fell in love with me," she declared,
and then added with no apparent irony, "The riots in my

unhappy homeland soon gave him the opportunity to prove how dear I was."

Proof of that devotion came with Repnin's refusal to follow orders from the Russian government that would have forced the Czartoryskis to bow to Russian authority. Only Repnin could say whether the reward was worth the price exacted; he was replaced by another ambassador. Not one to leave matters alone, Izabela became pregnant by him before he was forced to depart Warsaw for London. With the blessing of Izabela's husband, the infant was christened Prince Adam Jerzy and, according to law, became the heir to the name Czartoryski.

The Czartoryskis had lost their holdings within the Russian territories, but the family still owned several estates outside Polish territory not annexed by the Russians. Some were more grand than domestic, and it was a rural retreat in Powązki on the outskirts of Warsaw that Prince Adam Jerzy cited as the sentimental backdrop of his boyhood.

To understand why is easy. The Powązk property was a curated playground of indulgence—designed in part by Izabela, who had patterned it on Versailles's Trianon—where her principal courtiers, along with all of her children, were housed in individually designated cottages, each with its own garden. There was a large courtyard and stables. There was a forest; scattered in it were ancient ruins and a grove set aside for theatrical performances. There was a river with a mill. There was a lake, in the middle of which was an island that featured a grotto.

Perched on the hill looking down on this ordered

domain was a large house occupied by Izabela. In her cross sights was her son Adam Jerzy, a serious-minded boy who almost always had his nose in a book. Having already decided that he would one day play a public role in Poland's future, Izabela was determined to unlock his introversion. "Be liked more by all in general," she would tell him.

When it came time for him to be introduced to the rough elements he was destined to encounter as a man, Adam Jerzy was removed from Izabela's company, but the striving for Poland's independence that she had already impressed upon him would last for the rest of his life.

THIRTEEN

THE MOMENTUM of Poland's downfall was a grim reality check for the Czartoryskis.

With their fortune hanging in the balance, Izabela took it upon herself to make public pronouncements against Russia. Her agitations on behalf of Polish dissidents prompted her husband to suggest that she go abroad for a period of time. She welcomed the opportunity to visit Prince Repnin in London, where she stayed long enough to conclude that while its society appealed to her, England, as a whole, did not.

"There are two things I will never get used to," she wrote, "the atmosphere and the company. The first is too moist, the second too dry."

Izabela found refreshment from the dry company in England by having affairs with two Frenchmen stationed there: the French ambassador was one; the other was Duke Armand-Louis de Lauzun, who, catching sight of her at a London soiree, relayed to a friend, "A lady better dressed and combed than English women entered the room. I asked about her, and was told that she was a Polish

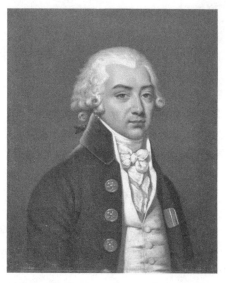

*Seen plainly in Duke Armand-Louis de Lauzun's portrait
is his dangerous attraction.*

Princess . . . [Her] gentleness in the manner of being and movements of unsurpassed grace proved that [a woman] who is not pretty at all, can nonetheless be charming."

Izabela hadn't been an outright rebel as much as a disrupter, but this affair would be different. When Izabela and her French duke crossed the channel to Paris, a fiasco trailed close behind, and faced with the inevitability of a forced separation—in the midst of their jumbled panic—the lovers conceived the drastic plan of a double suicide.

Whether the suicide bid failed from a faulty execution or it was never meant to succeed, Izabela soon returned to Poland. By then, she was pregnant. The duke—determined to stay by Izabela's side—arrived at the Czartoryskis'

Warsaw palace and introduced a screwball element to the drama by insisting that a maid hide him in a large wardrobe in Izabela's room while she gave birth. Being preternaturally open-minded, Izabela's husband was able to take his wife's theatrical entanglements in his stride and voiced no objection when she produced a second son not his, who was given the family's noble name and christened Konstanty Aleksander Adam Tadeusz Czartoryski.

Izabela's relationship with her French duke began to deteriorate after she accused him of infidelity. She distracted herself from disappointment with several affairs of her own. He returned to Paris, where his execution by guillotine during the French Revolution brought their tempestuous history to an end.

Duke Armand-Louis de Lauzun had been one of an impressive number of men in Izabela's line of lovers. They included a Polish nobleman, a French count, a diplomat, a politician, a military commander, and a traitor to Poland sentenced by the nation's Supreme Criminal Court, *in absentia*, to hang for treason. Whatever it was, whatever her appeal might be called—a restless charm, the enticement of temptation, or highly charged sexuality—it didn't appear to subside when Izabela's youth gave way to age. Self-control continued to elude her, and she had more children by more lovers: six, to be precise, none of whom had anything in common beyond their shared genetic material from their mother.

Izabela's hodgepodge of attributes presented themselves in phases, but always with cinematic fanfare. As a very young woman, her far-reaching enjoyment of life

made her an adventurous traveler—with or without her husband—as well as an enthusiastic partygoer who was fun company in short bursts. In her twenties, she spent the bulk of her mental energy on being good at men. She developed an interest in art and history and became a writer in her thirties. During her forties, she transformed herself into a philanthropist and a patron of the arts. A decade later, she wrote that "life is valuable in so far as it can be used to do something good." Determined that her firstborn son, Adam Jerzy, become a leader—perhaps even Poland's liberator—she made a point of involving herself in his upbringing.

As he grew from boy to young man, Adam Jerzy's political education increased proportionate to his age, and at nineteen he traveled to London to study the English constitutional and legal system. Accompanying him was Izabela.

"I can't deny that my son benefits immensely from his stay and that he needs me here . . . it's good that I came with him," wrote Izabela, oblivious to the fact her son wanted what most young men want—to chart his own course, ideally away from his mother.

A more objective report was written by one of their hosts during their tour of England and Scotland. "The young man, very tall and handsome, is deeply interested in the revolution in Poland in which I think his mother played a principal part—she is with him and took the direction of him . . . a woman that is still handsome, and said to be of great address of every kind but perfectly feminine."

While Izabela and Adam Jerzy were abroad, Poland—

already reduced to a Russian province—continued to sink into political chaos. The pinch point for the Czartoryski family was their refusal to take an oath of loyalty to Russia's empress, Catherine. Izabela returned to Warsaw. Adam Jerzy's own plans finally prevailed over his mother's political ambitions for him: he joined the army fighting against the Russians and served in a hopeless campaign.

With Poland's first two partitions, its borders were erased and redrawn in pencil. With its third and final partition in 1795, the commonwealth vanished from the map in a treaty that stated that "Poland in name or designation shall remain suppressed from now and forever." Austria took Kraków and the surrounding regions. Prussia occupied Poland as far west as Warsaw, where, on its outskirts, the Czartoryskis' rural residence in Powązki was destroyed. Russia advanced its frontiers beyond its borders, and its troops pillaged the Czartoryski estate in Pulawy. Sequestered were some twenty-five towns and 450 villages under the family's jurisdiction. Other estates held by the Czartoryskis—in Poland proper, in the Grand Duchy of Lithuania, and in the Ukraine—were all under threat of being forcibly sold.

Despite what had been the family's vast holdings, debts from lavish travel and patronage had exceeded their income. The unhappy fact was that the Czartoryskis were highly leveraged. With creditors baying at the doors, Izabela enlisted her onetime lover, the ever-reliable prince Repnin, to appeal to the empress Catherine.

There were many excellent reasons that Catherine became Catherine the Great. Arriving in Russia as a young bride speaking not a word of the language, she dethroned her husband barely six months after their marriage, overthrew her second cousin, and oversaw the country's transformation into one of the great powers of Europe and Asia. She was cold-blooded, single-minded, domineering, dispassionate in the pursuit of power, and brilliant at playing the long game. Unafraid of leading by example, she had herself inoculated against smallpox after informing her disbelieving government that she intended "to save from death the multitude of my subjects who, not knowing the value of this technique, and frightened by it, were in danger." After her own inoculation, some two million were administered.

Catherine's temperament and that of Izabela were not dissimilar, and with both women their characteristics became advantages rather than reasons for failures. Like Izabela, Catherine made herself into a hammer, and so everyone looked like a nail to her. Like Izabela, she considered remorse a useless emotion. Like Izabela, she had a deep-seated understanding of the nature of men. Clearly, she enjoyed sex, for, though the aggressive sexuality of her reputation has been exaggerated, questions remain as to whether any one of her three children was fathered by her husband, including the heir apparent.

Catherine, like Izabela, possessed more charm than beauty. Confirmation of this appears in the memoir of Madame Vigée Le Brun, a court painter to Marie Antoinette who, having left France during the Revolution,

enjoyed a peripatetic life by painting portraits of the illustrious in Europe's capitals.

Invited to St. Petersburg by Catherine, Vigée Le Brun wrote, "The sight of this famous woman so impressed me that I found it impossible to think of anything: I could only stare at her. Firstly I was very surprised at her small stature; I had imagined her to be very tall, as great as her fame. She was also very fat, but her face was still beautiful, and she wore her white hair up, framing it perfectly. Her genius seemed to rest on her forehead, which was both high and wide. Her eyes were soft and sensitive, her nose quite Greek, her colour high and her features expressive. She addressed me immediately in a voice full of sweetness, if a little throaty: 'I am delighted to welcome you here, Madame, your reputation runs before you. I am very fond of the arts, especially painting. I am no connoisseur, but I am a great art lover.' "

Suggesting that she was merely "a great art lover" was one of the rare instances that Catherine was afflicted with false modesty: the Hermitage Museum began as her personal art collection consisting of 320 pictures purchased from a Prussian diplomat pressed for cash. She was also a lover of books; thirty-eight thousand sat on her library shelves. She corresponded with Voltaire for some fifteen years and established the first state-financed higher education institute for women in Europe.

Of all the things Catherine was, more than any one thing, she was a masterful politician with extraordinary abilities to administer her vast country. Resolving to make its empire more prosperous and powerful, she extended

its borders by some 200,000 square miles, largely at the expense of the Ottoman Empire and the Polish-Lithuanian Commonwealth. It was Catherine who abolished the state of Poland after its eight hundred years of existence by dividing it between Russia, Prussia, and Austria. It was Catherine who made a point of seizing the estates of Poles who had openly expressed the aspiration for the independence of their country. To have gone against her had been a profound mistake for the Czartoryskis. When Prince Repnin appealed to Catherine to preserve the Czartoryski heritage, she expressed a mild willingness to consider releasing the family's confiscated properties, but only at a future time and with one condition.

"Let their two sons come to me," she told Repnin, and then, to remind the Czartoryskis of how horribly unwise they had been and that whatever happened next would be solely up to her, she dangled, "We will see."

Left with no choice, Izabela and her husband sent their two sons to St. Petersburg to serve the very woman who had brought Poland to its knees before making it disappear entirely.

"OUR FATHERLAND WAS LOST . . . Were we also to con-
demn our parents to that, and make it impossible for them
to discharge their debts?"

This was the rhetorical question asked and answered by
Prince Adam Jerzy. "It was the most painful sacrifice we
could make," he wrote, "for to do this, it was necessary to
act in opposition to all our sentiments, all our convictions,
all our plans—to everything that was nearest to our hearts
and minds."

He was twenty-five when he and his younger brother,
Prince Konstanty Adam, arrived in St. Petersburg by car-
riage in May 1795. At stake was the credit of their fam-
ily name, its entire holdings, and its social and political
status—indeed, its very survival. Accompanying them
on their uncertain course were two elderly gentlemen
assigned by the family to assist, if at all possible. Prince
Repnin, who had negotiated details of the arrangement,
continued to make himself available.

Adam and his brother were not suppliants, but theirs

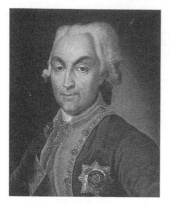

*Nikolai Repnin was the biological father of
Prince Adam Jerzy Czartoryski; both appear darkly handsome
and stormy-faced.*

was a bitterly humiliating mission that they could neither
evade nor ignore. They came freely to Russia to offer their
services to the court of Catherine the Great, the woman
who had conquered and dismembered their homeland.
Had they not, she would have rewarded the Czartoryskis'
landed property to her Russian generals and diplomats.

It wasn't the first trip made to St. Petersburg by mem-
bers of the Czartoryski dynasty. With hopes of shoring up
the political disarray of the Polish-Lithuanian Common-
wealth, there had been a multigenerational effort to gain
support from notable Russians. Adam Jerzy's grandfather,
his great-uncle, and his father all made the journey, and
each left empty-handed.

Catherine's accession to power and subsequent rule
relied on the wellborn, and for that reason she was inclined
to surround herself with titled aristocrats. She admired

the noble tenacity of the Czartoryskis, but as a reminder to them that she, and she alone, was pulling the strings, rather than releasing the family's confiscated properties outright, she agreed to gift a large sum of money to Adam Jerzy and his brother as long as they remained at her disposal in St. Petersburg. Catherine had war-gamed the outcome brilliantly: the two had no recourse but to stay in her court and grant their father full power to dispose unconditionally of the fortune ceded to them in order for him to repossess most of the family's estates and its land.

Adam Jerzy confronted the circumstances forced upon him with a combination of hard-earned realism and subdued determination: he recognized that serving Poland's cause would be made impossible by his extremely restricted circumstances; at the same time, he was determined not to be entirely separated from his nation.

"This phase of my life produced deep and painful results," he admitted dolefully. "The defeat of justice and the triumph of violence had unhinged my mind. Every Russian seemed to me an author of the misfortune of my country."

The young prince had managed to save his family from public humiliation, political ignominy, and financial ruin, but it came at a heavy cost; more than once did he lapse into despair. His attitude changed with time. He came to know and even enjoy his contemporaries in St. Petersburg who shared his liberal views. One was the nineteen-year-old grand duke Alexander, Catherine's eldest grandson and heir to the imperial crown, who felt free enough with Adam Jerzy to openly express the opinion that at some

point Poland might regain its independence. The trusting relationship that developed between them resulted in one of the more stunning political paradoxes: an ardent Polish patriot sent to Russia on a forced mission had become a close friend to the future tsar.

"He was under the charm of early youth, which creates images and dwells upon them without being checked by impossibilities," was how Adam Jerzy described Alexander, after Alexander expressed the opinion that hereditary monarchy was an unjust institution and that the supreme authority should be granted not by the accident of birth but by the votes of a nation.

St. Petersburg society was almost entirely composed of Catherine's family and her courtiers. All of them enjoyed gossip, and most of them took part in a kind of nonchalant nastiness. It must have been luck alone that saw to it she was never privy to the political sentiments swapped between her grandson and his Polish confidant. So involved had Catherine been in her grandson's upbringing that when he was a boy, she separated him from his parents and sequestered him in a private apartment in the palace. He was barely fifteen when she arranged his marriage to the fourteen-year-old princess Louise of Baden, a niece of the queen of Prussia who—to accommodate her new role—took the name Elizabeth Alexeievna.

With no real interest in his wife, Alexander decided to release her from the obligation he himself had no intention of honoring—marital fidelity. The why of this is a question one must be willing to leave unanswered: it wasn't that Alexander was off women; he seemed to enjoy himself

with a wide array of them. It could have nothing whatsoever to do with Elizabeth's appearance; she was considered one of the most beautiful women in Europe. Nor could Alexander have had objections to her demeanor, which was full of grace and dignity. He was unable to claim that Elizabeth had an unappealing personality; she was charming and generous in equal measure. As for gaps in her intellect or intelligence, none existed: she was an appreciator of literature and an enthusiast of music.

Not one of Elizabeth's notable qualities did anything to impress her husband. That's not to say that she went unnoticed by another man.

Even a cursory look at Adam Jerzy's portrait would reveal a blend of aloofness and formality. Rarely did he admit to his emotions, even among his own family members, and the few times he did, he made a point of keeping concealment in reserve. No one could have predicted that, ignoring the consequences of allowing rationality to let down its guard, he would fall passionately in love with Elizabeth, despite her marital status, aware that it would be an obstacle to his growing friendship with her husband, and knowing that the repercussions would put him in a vulnerable position with Catherine, on whom he and his family depended. It was nothing short of a miracle that in the remaining years of her life word of the affair never reached her.

Catherine had a long run on the throne, and when her death came, Adam Jerzy likened it to a deafening clap of

thunder over Russia. His journal entry reported, "The Empress had an apoplectic stroke . . . Those who had the entry to the Court went there with a feeling of terror, of anxiety, and of doubt as to the future . . . All was disorder, and etiquette was abandoned . . . Most of those who were present in the room expressed sincere grief; the pale and distorted features of many betrayed a fear of losing the position they enjoyed and perhaps of being obliged to render an account of their administration. My brother and myself were among the spectators of this scene . . . We entered the room where the Empress was lying . . . lifeless, like a machine whose movement had ceased."

The reign of Catherine's son Tsar Paul lasted only a short while, but it was long enough for him to become aware of Adam Jerzy's devotion to Elizabeth. His suspicions were confirmed by his granddaughter at her christening when it was impossible to reconcile her dark eyes and hair with two blond, blue-eyed parents.

Paul ordered that Adam Jerzy be banished to Siberia. Cooler heads prevailed, and the punishment was downgraded to a marginal ambassadorial role in another country. With the appointment of minister plenipotentiary to the court of Sardinia, whose monarch had no kingdom, Adam Jerzy was able to slip out of Russia without too much incident. Arriving in northern Italy, he made a visit to Verona, followed by ones to Venice and Mantua. With more time in the winter, he traveled to Florence, where he wrote his mother that it would be "impossible for one who knows something about the arts and literature of antiquity not to feel their influence," but that Italy as a country—

having passed from one conqueror to the next—was in a pitiable state.

Subsequent, less atmospheric letters from Adam Jerzy to Izabela made obvious that the enforced absence from his own country, as well as from St. Petersburg, was exacting a price on his mental health. Separated from Elizabeth, and heartbroken after learning of his daughter's death shortly after he left Russia, Adam Jerzy might have been able to keep his melancholy in check had he been given a more serious and challenging purpose in Italy. Instead, the flimsy remit assigned to him were monthly written reports he was expected to send to St. Petersburg on the activities of the French Republic in Italy.

Consciously simmering for some time had been Izabela's idea to re-create Poland's past with a collection of carefully selected artifacts. Made aware that her son was languishing in Italy without purpose, she asked him to source antiquities in Italy for what she decided should be a national museum in Poland.

AS SOON AS THE Czartoryskis' replenished finances enabled them to retrieve their confiscated properties in the Russian partition of Poland, Izabela marshaled her creative energies to salvage the Pulawy estate that had been sacked by Russian troops. It was a pitiful ruin. Valuable paint-

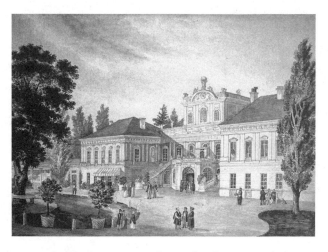

After Russian troops gutted most of it, the Czartoryskis'
rebuilt Pulawy estate was given a second life.

ings had been cut in pieces, books from the library had been stolen, the palace's ornamentation was either broken or damaged beyond repair. The only room spared was one with gilt wainscots and pictures of Boucher over the doors; the soldiers had thought it a chapel.

Izabela enlisted Polish craftsmen to restore what they could of the palace and to rebuild the rest. She hired a Scottish landscape architect, and together they transformed the vandalized grounds of the estate into the likeness of an English park. Untroubled by her lack of writing experience, Izabela penned and published the first Polish book on gardening, titled *Thoughts on the Manner of Planting Gardens*.

"I feel that I am undoubtedly sinning on all sides, unfamiliar with the laws of writing," she confided in correspondence, "but my husband, who sees everything in me from a good side, is convinced that this is good and graceful."

Izabela's innumerable extramarital exploits had made her husband a seasoned player when it came to the melodrama that seemed to congregate around her; in light of the arduous support it required of him, the less demanding expectation of an endorsement for her writing must have come as a welcome relief. By then, things had changed between the two of them. Until the midpoint of her marriage, Izabela shaped her life outside it. After the devastation of Poland's third partition, she took on solid purpose and joined her husband in a shared commitment. The two devoted themselves to a much-hoped-for resumption of Poland's position among the independent states of Europe.

*Izabela created the first private collection in Poland to be housed
in a museum that was open to the public.*

Believing that the starting point from which to advance
the nation once again was to be found in the unique inti-
macy between the Poles and their past, Izabela wanted
to reestablish the Pulawy palace as a meeting place for
poets, writers, and artists she considered prophets of
patriotism—ardent spirits who kept alive the flame of
Polish independence. Her husband—known for his intel-
lectual wattage—recruited followers of the Enlighten-
ment, a movement dominating the world of ideas based
on rational examination and objective evidence. Here,
too, Izabela played an increasingly relevant role when she
had built a colonnaded, round, temple-like structure of
her own design on the estate. Her Temple of Sibyl (also
known as the Temple of Memory) was one of the first
publicly accessible museums in Europe, preceding the Pal-

ace of Versailles's Museum of the History of France by some thirty years.

Having seen firsthand the dismemberment of Poland, Izabela cleaved to the view that the purpose of her museum should be to preserve the nation's history, to safeguard its culture, and to signal its virtue. "My homeland, I was not able to save you, let me immortalise you at least" was her declaration. But restraint was never among Izabela's skills, and she began to expand the collection of Polish artifacts to include valuable relics of European history. Supported by various other benefactors she pressed into action with her unremitting energy and bravado; the result was a wide-ranging assemblage of items that included chairs belonging to William Shakespeare and Jean-Jacques Rousseau, fragments from the alleged graves of Romeo and Juliet in Verona, ashes of El Cid, Isaac Newton's death mask, and relics of Abelard and Héloïse. Though historical artifacts were what Izabela was most interested in collecting, when favorable circumstances presented themselves, she acquired pictures, and either by design or by her wiles she managed to get her hands on Rembrandt's *Landscape with the Good Samaritan,* purchased at a Paris auction by a French-born Polish intermediary.

Adam Jerzy continued to correspond with his mother during the sojourns he took to Verona, Venice, and Mantua. He was likely purchasing artifacts in these various cities for her, borne out in one of her letters to him in which she wrote, "I am most delighted with the curios you have chosen for me, and for those you've promised. The Scipio's urn and the obelisk are exquisite pieces."

———

As soon as the king of Sardinia and his court learned that French troops had successfully crossed the Alps, they decamped to Rome. Adam Jerzy continued corresponding with his mother, writing that "one gathers together all of one's recollections, one strives to remember all one has learnt, read, and heard of this ancient capital of the world, and it is difficult to realize the idea that you are really at the spot where great events have occurred, that you tread the soil trodden by such great men."

While Adam Jerzy was devoting himself to his leisurely exploration of the ancient culture of Italy, another young foreigner arrived with a more pressing agenda: at the age of twenty-six, Napoleon Bonaparte intended to establish a global empire.

———

When Napoleon arrived in northern Italy, he inherited an underfed, under-equipped, unpaid, ragtag army, and it took him less than a year to transform it into an effective force against the Austrians. By 1799, he had conquered most of Italy and had systematically split up its Austrian holdings, replacing them with satellite republics of France. Enabling France to afford Napoleon's endless military campaigns was a self-financing method of levying crushing indemnities along the way. The Italian nobility was dealt a double blow: they lost their federal rights and were forced to pay punitive taxes by Napoleon's administrators.

As a roving ambassador, Prince Adam Jerzy could very

well have known about asset-rich but cash-poor noble Italian families forced to sell a picture or two. Seduced by simple logic, one might come to the conclusion that at some point that year—probably in one of the Italian cities through which he was traveling—he purchased a picture small enough to carry away without too much inconvenience. The seller remains a mystery to this day. The recipient is not. In 1800, *Lady with an Ermine* became Adam Jerzy's gift to his mother.

Neither mother nor son could possibly foresee the significance the portrait would have in the centuries to come.

SIXTEEN

AFTER YEARS OF STANDING BY MUTELY while Catherine the Great blocked him from becoming involved in any form of political and government administration, her son Paul was in his forties by the time she died. When he was finally given his chance on the throne, it took him no time at all to prove that he was a disaster.

As Russia's tsar, Paul I exposed the country to incalculable calamities. He governed according to his impulse of the moment while his court stood by helplessly, knowing how impossible it was to constrain or confine his maniacal rule. Despite Tsar Paul's love for the military, it did not love him back, so it should have been relatively easy to force an end to his volatile four-year regime. Instead, there was a spur-of-the-moment messiness to it. When a group of nobles insisted he abdicate, he refused. They mobbed him and it became a free-for-all. The gruesome mix of fatal injuries included strangulation, trampling, and a sword thrust.

Adam Jerzy's ambassadorial role in Italy was brought to

an abrupt end on March 17, 1801, with a letter from Prince Alexander, who, having nothing to do with the assassination, was crowned emperor over his father's dead body.

"You have already heard, dear friend, that owing to the death of my father, I am at the head of affairs," he wrote to Adam Jerzy, and then hastened to add, "I do not mention any details, as I wish to give them to you by word of mouth. I write to ask you at once to hand over all the affairs of your mission to the next senior member of it, and to proceed to St. Petersburg. I need not tell you with what impatience I am waiting for you. I hope heaven will watch over you during your journey and bring you here safe. Adieu, dear friend, I cannot say more. I enclose a passport for you to show at the frontier."

Returning to Russia, Adam Jerzy stopped at Pulawy and brought with him two gifts for his mother: Raphael's *Portrait of a Young Man* and Leonardo's *Lady with an Ermine*. The pictures might or might not have come from the same person or family, though they were almost certainly purchased in Italy. There are no surviving documents recording a transaction for either portrait, but Izabela's notes indicate that Raphael's portrait was purchased by her "older son from the prominent Giustiniani family in Venice."

This doesn't quite square.

According to Adam Jerzy's own journal, he had precious little opportunity to acquire anything of importance during the brief time he spent in Venice. Far more probable is that he purchased both Raphael's portrait and *Lady with an Ermine* through an intermediary, possibly acting

The masonry of Izabela's Gothic House was, in part, pieces of stone from historic buildings and sites in Italy, Spain, and Portugal.

on behalf of the noble Venetian Giustiniani family, in a city other than Venice.

Izabela wasn't as worried about the picture's provenance as she was where to hang it, for by then she could choose between the Temple of Sibyl and a newly constructed gar-

den pavilion that had been built nearby to accommodate her expanding collection. The pavilion was referred to as the Gothic House. Displayed above its entrance was a quotation from the *Aeneid:* "Things cry with tears and, although they are dead, they can wrap fingers around the heart."

No ownership records exist for *Lady with an Ermine* before Prince Adam Jerzy made a gift of it to his mother; nonetheless, he knew it to be a Leonardo. His certainty was documented in Izabela's handwritten notes, whose loosely translated entry from French reads, "This charming painting, which looks quite like a portrait, was painted by the famous Leonardo d'Avinici. My older son, who brought it from Italy, gave it to me. It depicts a girl pressing a small animal to her chest. Extraordinary truthfulness of the whole character, naturalness and freedom of pose, the proper color only gives this great painter great value to an image which, although very old, is exquisite. The animal held by a young person is hard to describe. If it was a dog, it would be ugly; if any other animal, I don't know it. It is white, its feet are very short and its head quite large. The girl looks about 15 years old . . . her hair is tied with a simple ribbon."

Izabela also provides a valuable piece of information on the state of the picture when she writes, "Although very old—it is preserved splendidly." Hers was not an inaccurate assessment: by then, the portrait was more than three hundred years old. It is thought that at some point at the end of the eighteenth century a thick walnut panel had been glued to an oak cradle backing it.

Requiring that each of her museum's exhibited portraits testify to history, but unsure of the identity of the young woman in *Lady with an Ermine,* Izabela blithely assigned one of her own. After inspecting an etching of Leonardo's *La Belle Ferronnière,* she decided that because the woman in that portrait looked like the one in *Lady with an Ermine,* they must have been one and the same. The erroneous identity of the portrait's subject, along with Leonardo's name, was inscribed in Polish on the top-left corner. In that same corner appears slight and confined damage suffered by the portrait at a previous but unknown time.

Izabela hung *Lady with an Ermine* in the Gothic House on the grounds of the Czartoryskis' Pulawy estate. There are no written testimonies of how—or even if—the portrait had an impact on those who saw it, for, according to guest books, a greater number of people visited the more prominent Temple of Sybil, but making its own important contribution was the Gothic House's catalog, because it included a history of Leonardo—one of the first in the Polish language—along with Izabela's anecdotal description of *Lady with an Ermine:*

"This Picture, painted by Leonardo d'Avinic, is to be a portrait of Franciszek I's mistress, King of France. They called her La Belle Ferroniere, she was to be the wife of a merchant who owned an iron shop. Others said that her husband was a patron. The King's courtship and Leonardo's brush strokes establish the value of this picture. The person seems to be young, slim, gentle. The clothing is very modest."

It could be said that history is our collective memory

in a world intent on forgetting and that portraits serve as a record for people to be remembered. When *Lady with an Ermine* left Italy, some part of that country went missing, too, and when the unique being depicted in the portrait was misidentified, lost as well was the very essence of Cecilia.

SEVENTEEN

"YOU WERE RIGHT TO COME," was Tsar Alexander's short but consequential greeting when Adam Jerzy arrived at the Royal Palace in St. Petersburg from Pulawy.

Those five words were the building blocks of Czartoryski's future—and extremely unlikely career—as a Russian statesman.

With Adam Jerzy so closely positioned to Alexander, the Russian court and government found it difficult to read the tsar's intentions—as though they had been given a book wherein each page was actually two pages: one superimposed on the other, leaving the overall narrative almost impossible to decipher.

Adam Jerzy himself understood just how precarious were his circumstances when, at the age of thirty-four, he was given a decisive role in the affairs of Russia's government—the result of Alexander's appointing him Russia's minister of foreign affairs. He wrote that "a Pole enjoying the confidence of the Emperor and being initiated into all secrets of State was, to most, an intolerable innovation."

Sensing that her son was operating beyond the law of political gravity, Izabela urged him to set a limit on his work and, once he achieved his objectives, to return home to what was left of Poland. Instead, he became an important player in reorganizing the Russian government's inner sanctum. He agreed that Russia should defend itself, but he also pointed out that the progress made by nations bordering Russia would, by no means, lessen its own progress. On foreign matters, he had been right to warn of French ambition, specifically that of Napoleon, who would lay the foundation for postrevolutionary France with reforms that included a newly established legal code, the lycée school system, and a central bank. (His record also qualifies him as a colonizer, a warmonger, and an enslaver.)

After the collapse of the Napoleonic era, Adam Jerzy was convinced—some would suggest, naively—that the future of Poland might still be independent from Russia. He tried mightily to impress upon Tsar Alexander that the economic interests of Russia and Poland were mutually compatible. Adding weight to this advocacy was the foresight that if united German powers were one day to threaten Russia with invasion, a wholly restored Poland would be in the best military interest of Russia.

Efforts by Adam Jerzy to build a consensus within the Russian government paid off: an agreement in principle was made to reinstate the Polish state with its own constitution, parliament, army, and currency. The Congress of Vienna changed the partitioned boundaries in the west: the Prussians fell back; Kraków became, in practice, a free city; and what remained was declared a semiautonomous

region of the Russian Empire, the so-called Kingdom of Poland.

It was with a sense of permanence that Izabela settled at Pulawy and established the first in a number of elementary schools in the region. Taking up residence in the palace were older students whose artistic talents she nurtured. One was a dark-eyed, dark-haired, slim young woman by the name of Cecylia Beydale, who spoke with a heavy French accent. She developed a close friendship with Izabela's older daughter. She also fell in love with Jerzy's younger brother, Konstanty, who had married into the Radziwiłł family and returned to Pulawy as a widow.*

Cecylia Beydale's ardent feelings for Konstanty were reciprocated, but when he proposed marriage to her, Izabela declared it impossible. They could never be man and wife, she told him, because they were already brother and sister.

When Izabela was in her early forties, she had another of her dalliances—this time in Paris. It resulted in the birth of Beydale, who was left behind in the care of an unnamed woman. Aged fifteen and unaware that Izabela was her mother, Beydale was sent to Pulawy in the guise of a talented music student. Because it was in Izabela's nature to take and dismiss things easily, she remained untroubled by the consequences of her disclosure. It's not known how Konstanty reacted to the devastating revelation. Cecylia Beydale never recovered.

* Jacqueline Kennedy's sister, Lee, would marry into this same noble Polish family.

The Kingdom of Poland remained a theoretical exercise for Tsar Alexander until he realized how capricious it would be to relinquish the partitioned area of Poland that had become Russian territory, and so, despite the close relationship he had with Adam Jerzy, he retracted the freedoms that were previously granted to Poland as a fully sovereign state.

In defiance, Poland's parliament continued to meet.

Adam Jerzy had been treading a path of conflicting political interests long before, but now he found himself in an existential deadlock, forced to choose between his own nation and Russia's tsar. He wrote to Alexander but received no response. Hearing nothing, he wrote him again. Still no answer. Writing a third time from the Czartoryski family estate in Sieniawa, Adam Jerzy informed Alexander that unless he heard from him within six weeks, he would consider the silence consent for him to resign his post as Russia's foreign minister and join his Polish countrymen. Six weeks after that, Prince Adam Jerzy was officially absolved from his duties as Russia's foreign minister.

"My dear friends, so we become enemies," is how he addressed his Russian colleagues. With the same searing frankness he warned that "the hatred on both sides will be exacerbated and it will not be appeased until the day when, after much bloodshed, it will be at least understood that the happiness and glory of one of our two nations are not necessarily to be founded on the oppression and misfortune of the other one."

Izabela's husband died in 1823 and bequeathed the Pulawy estate to Adam Jerzy, who left its management to his mother while he traveled the next four years. What he did during this period is unclear, but there must have been some contemplation on his part, for his struggles against overwhelming odds had not just been political; they included his love affair with Elizabeth. Whether the result of his exhausting fits of conscience or a willfully blind state of mind, Adam Jerzy—more in hope than sober analysis—had asked Alexander to divorce Elizabeth. The inevitable answer left him with overwhelming sadness. The final blow was suffered several years later at Elizabeth's death. In one of the rare occasions that he ventured to express his emotions, Adam Jerzy wrote to his sister, lamenting, "Since the moment when I heard of her death I do not know anymore what I want or what I ought to do. I was always thinking of her. She constantly was the aim of all my action."

With Elizabeth gone, Adam Jerzy took as his wife a young princess whose mother (née Zamoyska) was attached to a large fortune. Like that of his parents, the marriage would be what the French referred to as *un mariage de raison* (a marriage of convenience), and just as it had been with his parents' union, over time it would grow to something more.

When Tsar Alexander succumbed to typhus in 1825, he left behind no legitimate children and two younger brothers, neither of whom wanted the crown—or, more accu-

rately, what the crown entailed. A period of chaos and confusion followed until one of them, Nicholas I, agreed to succeed to the throne.

Tsar Nicholas I was wholly lacking in tolerance, particularly when it came to any form of dissent. He was consumed by discipline, he embraced a singleness of purpose, and he was devoted to duty. All of these unyielding traits would come into play with the political issue confronting him of what to do with Poland. When the time came to make a decision, it was no great surprise that he refused to bow to the views of the Poles that he make good on the commitments to which his older brother Alexander had agreed but failed to deliver. While Polish radicals demanded total independence, Adam Jerzy worked tirelessly toward a peaceful solution, hoping that the fate of both countries would be decided by diplomacy rather than being dictated by force.

For Izabela, the past had already surged up with vivid memories of Poland's previous armed insurrections, and she took the precaution of evacuating the Czartoryski collection from the Pulawy estate. Certain objects in the Temple of Sybil and the Gothic House were scattered to safe locations, while some thirty thousand books, along with the family archives and the more precious art and artifacts of the museum, were moved under the cover of night one hundred miles south to the family's palace in Sieniawa within the Austrian-designated partition. To protect it from harm or theft, *Lady with an Ermine* was walled away in the palace's alcove.

On a November evening in 1830, a small party of Polish

officer-cadets attacked the residency of the Russian vice-roy. Polish civilians joined their ranks to overpower the city's arsenal. The following months of violence saw sacrifice that cut across the socioeconomic divide: Polish nobility formed their own cavalry squadrons. Peasants formed a commune of insurrectionists, arming themselves with pikes made out of scythe blades.

Izabela was eighty-four when, in 1830, her son Adam Jerzy became head of the Polish government. That same year, she watched the Pulawy palace come under attack by a Russian regiment commanded by her grandson, for it happened that one of Izabela's daughters had married a German aristocrat in Russian service. In light of this fact, another—that he became a general in the Russian army—might not have been as convoluted as one might have thought. But that her grandson was in charge of a battalion that laid siege to the Czartoryskis' palace was the most implausible of the many barely believable aspects of Izabela's life—a life that had already been crowded with incident and coincidence.

The November Uprising—as it came to be called—lasted a month shy of a year, from November 1830 to October 1831. Izabela died four years later at the family's estate in Sieniawa, where, hidden in a dark cellar room, slept *Lady with an Ermine*.

EIGHTEEN

THE FAILED NOVEMBER UPRISING left behind irreversible destruction: the Kingdom of Poland's parliament was finally eliminated and its administration entirely purged; its institutions were abolished, including its bank; its system of currency disappeared, along with its weights and its measurements.

With no negotiated surrender, Tsar Nicholas I had a free hand in dealing with what he considered Polish rebels. Hundreds of them were executed on the spot. Some 180,000 were deported, while others were sent to Siberia and forced to labor in the mines, often for life. The most lenient punishment was compulsory service in the ranks of the Russian army lasting twenty-five years.

Prince Adam Jerzy had sacrificed more than half of his personal fortune to salvage Poland's connection with the Russian Empire. Unwilling to leave it at that, Tsar Nicholas appointed a special criminal tribunal that found him guilty *in absentia* of treason. Due to the princely rank of the family, his punishment—death by beheading—was

The Polish Prometheus, *by Horace Vernet, is an 1831 allegory of the November Uprising and left no doubt of the outcome.*

reduced to permanent banishment, and he was executed in effigy.

The confiscation of Czartoryski properties in the Russian partition brought to an end one of the greatest landed fortunes in Poland. Adam Jerzy managed to find a certain peace of mind in his material ruin, writing, "It has come in a costly and violent manner, but I feel happy to be released from bonds by which I had been fettered . . . and surely I shall not return to take them again, even at the cost of all my fortune."

By drawing on his perseverance as statesman and the rare gift of a politician willing to ignore previous injury, he was able to hold on to the belief that his country was

not dead, only asleep. His ideological activities continued despite his exile, first in London, and next in Paris, a city fast becoming a Polish hub for clannish aristocrats.

It wasn't just Poland's political and military leaders who had become outlaws in the land of their birth: the outflow of Polish writers, artists, and musicians was the most extraordinary collection of talent that transferred itself from one country to another—some ten thousand in all. In Paris, the Czartoryskis became major patrons of the Polish arts; among their beneficiaries was a brilliant twenty-one-year-old pianist and composer who had joined the expatriate community after leaving his hometown of Warsaw not long before the outbreak of the November Uprising. He was Fryderyk Chopin.

Eugène Delacroix lived in Paris at the same time Chopin took up residence. Delacroix was more than a revered painter; he was a skillful musician. The two men became close friends, and one afternoon Delacroix invited Chopin to accompany him to the Île Saint-Louis to look at the murals by Charles Le Brun located in a derelict *grand hôtel particulier* scheduled for demolition. Chopin's description of the property to his patron, Adam Jerzy, was enough of an enticement for Prince Adam to see for himself.*

The better part of Adam Jerzy's life had been spent in constant motion. He must have decided that the time had come to purchase a permanent Parisian residence, one large enough to accommodate the extended family and

* Charles Le Brun was an ancestor by marriage to Élisabeth Vigée Le Brun, the artist who painted the portrait of Adam's father and who, invited to St. Petersburg by Catherine the Great, wrote about her in vivid detail.

his sizable entourage. Successfully outbidding the City of Paris, which wanted the land for a new public library, Adam Jerzy purchased the Hôtel Lambert in 1843.

Built between 1640 and 1644 for its namesake—a wealthy financier—the Hôtel Lambert was designed in large part by Louis Le Vau, who was involved in the design of the Palace of Versailles as well as the Louvre Colonnade, a notable example of French classical architecture. Located on the very tip of the Île Saint-Louis, the *hôtel* was constructed around a central interior courtyard. So vast was the property that the sixty-some servants on the premises were never seen unless they were summoned.

Breathtaking reception rooms occupied the first floors of two of the four wings; another wing of the palace became the seat of Prince Adam's political offices, from which he continued to mobilize public opinion on behalf of his homeland. By the mid-1840s, in a time when Polish identity and its very language were being threatened, the Hôtel Lambert became an important center of Polish culture frequented by Polish and Parisian intellectuals and artists. Among them were George Sand, Honoré de Balzac, Hector Berlioz, Franz Liszt, Delacroix, and, of course, Frédéric Chopin, who composed one of his polonaises exclusively for the Czartoryskis.

Lady with an Ermine had been retrieved from its hiding place in Sieniawa and transported to the Hôtel Lambert, a place deserving of its beauty. Despite the stream of visitors coursing through the *hôtel,* the masterpiece remained in residence with remarkably few people aware of its existence. Assuming that it was hanging in a room located in

Depicted by the Polish painter Teofil Kwiatkowski was the annual
Polish Ball in the Hôtel Lambert (decorated with temporary vaulting).
Prince Adam (to the left) listens to Chopin, who is at the piano.

one of the family's private apartments on the second floor, someone with the best chance of seeing it was Delacroix, and it's been suggested that it was, in fact, Delacroix who was asked by Adam Jerzy to change the color of the portrait's background.

With the recent benefit of scientific data, specialists in the field of restoration are confident that the picture's background was originally a bluish-gray color. However, there are conflicting theories as to when, exactly, the color was changed. While some scholars insist that the portrait's background was its unmodulated black when Adam Jerzy purchased it in Italy, others suggest that the background had been overpainted later and possibly by Delacroix. The second of the two theories doesn't sit easily with Delacroix's reputation beyond that of an artist, for, not only did he paint and play musical instruments brilliantly, but

he was a prolific writer: some seventeen hundred of his letters have been published; his journal, with its connected notes, runs more than 850 pages and features a cast of more than a thousand people. That Delacroix was both diligent and truthful in recording his daily life casts serious doubt that he would have omitted a mention of *Lady with an Ermine*—less likely still that he was involved in any alteration of it. The debate is irresolvable. Questions, then, continue as to when, where, and why the background was changed and by whom. As for the choice of the replacement color behind Cecilia, perhaps it is as it should be. Black is an unbound color and, being limitless, suspends her in time.

———

After thirty years in exile without achieving Poland's salvation, Prince Adam Jerzy Czartoryski's complex, surprising, resilient, and often contradictory life came to its natural end on July 15, 1861. His remains were transferred to the parish church in Sieniawa to lie in the family crypt next to his mother.

Chopin's body rests at Père Lachaise in Paris. At his instructions, his heart was brought back to his native land to be entombed at the Holy Cross Church in Warsaw.

The Hôtel Lambert remained in the Czartoryski family.

Taking her last breath in that very place was Cecylia Beydale, having never recovered from the disclosure that Konstanty Czartoryski, her intended husband—a man with whom she was desperately in love—was none other than her brother.

PRINCE ADAM JERZY'S SECOND SON, Wladyslaw, was just as dedicated an art collector as was his grandmother Izabela. It was not unexpected that his father's will designated him the owner of the family's collection.

Aware of the ever-increasing value of the family's collection, Wladyslaw established what is referred to in Polish as an *Ordynacja,* whose English translation comes closest to an "ordinance council." This entailed the collection and its assets into an inalienable inheritance that would continue to pass to the eldest male heir and ensure that the estate could not be sold or otherwise disposed of by any incumbents.

Taking an active interest in sharing the Czartoryski collection with the public, Wladyslaw curated "the Polish Room" at Paris's 1865 Exposition des Arts Décoratifs. While it featured 388 objects, *Lady with an Ermine* remained in the Hôtel Lambert, away from the public's gaze. That was apparently also the case when, two years later, Wladyslaw decided to allow the collection in the

Prince Adam Jerzy is seated, and, to the right, looking equally solemn and no-nonsense, is Wladyslaw.

hôtel to be seen by limited members of a discerning public. The brief description in the brochure read, "At the Hôtel Lambert the principal wonders are armor, jewels, and an infinite quantity of objects d'art . . . a portrait of Holbein of extraordinary beauty, a Clouet, a series of admirable little portraits by Cranach, an extremely rare landscape by Rembrandt, a few Italian portraits and many historical ones." No mention was made of *Lady with an Ermine*.

The latter half of the 1860s was fraught with political tensions between Prussia and France as the balance of power in Europe shifted. Having read the direction of the

wind, Wladyslaw relocated to London with his family. They were living in a house on Half Moon Street off Piccadilly when France declared war on Prussia. Lasting six months, one week, and two days, the Franco-Prussian War was a contest of national wills that resulted in a series of humiliating defeats for France, which had been unaware of the scale of the German army and the efficiency of the Prussian railroad system that made possible the lightning-fast deployment of troops and equipment.

As German and Prussian forces were tightening their stranglehold on Paris, curators at the Louvre emptied the museum of its most important artworks. By the time German troops overtook Paris and Chancellor Bismarck insisted on seeing the museum, its rooms contained only empty frames.

The cessation of hostilities didn't put an end to the nightmarish state Paris had become: on the heels of its occupation by combined German and Prussian forces were radical French revolutionists, who, clashing with moderate Republicans in the government, incited riots for the two bloody months it took to suppress them. It's not known whether *Lady with an Ermine* was among the Czartoryski valuables moved to the cellar of the Hôtel Lambert during the chaos. A sentimentalist would have you believe that because the picture was small enough to pack with Wladyslaw's personal items, he might have taken it with him to London. Had that been the case, he wouldn't have been the first collector to hold on to a personal favorite. Sir George Beaumont, who played a crucial part in the creation of London's National Gallery by advocating for its formation

and donating pictures from his private collection, with-held a small picture he adored, Claude Lorrain's *Hagar and Ishmael*. No matter how brief a journey, it traveled with Beaumont in his carriage for his uninterrupted enjoyment.

Polish scholars are less confident about *Lady with an Ermine*'s possible exile to London and insist that it remained in Paris, out of danger and hidden in the Hôtel Lambert. Arsène Houssaye, a Frenchman of the time, pro-posed a third theory.

Playing, as he did, fast, loose, and, sometimes, hilari-ously with the truth, Houssaye wasn't a flat-out liar, but as a source of accuracy he is an iffy proposition. Born in a small town in northeast France, he moved to Paris at the age of seventeen and fell into an amnesic relationship with his past by changing his family's name from Housset to lay claim to a nonexistent aristocratic lineage.

Houssaye was someone who intermittently gave the impression of being an intellectual without actually being one. Those with a place in Paris's intellectual inner sanc-tum considered him to have less intelligence than might have been expected from someone so clever. But what Houssaye lacked in intellect and intelligence, he made up for in productivity. His numerous activities included writing two novels and collaborating on a third with the writer Jules Sandeau, the onetime lover of George Sand, who appropriated part of Sandeau's name to fashion her own pseudonym.

Houssaye must have known that Sand attended the per-formances of Chopin (her former lover) at Czartoryski's Hôtel Lambert. Unclear is whether *Lady with an Ermine*

Houssaye cultivated an edgy look, and even without the benefit of
André Gill's caricature he was seen as distinctly odd.
It was discovered that one of the books he wrote, now owned
by Harvard University, was bound in human skin.

was mentioned in conversation; nonetheless, Houssaye insisted that the portrait went missing in the pandemonium of Paris after the Franco-Prussian War. He offered no evidence to back up this declaration but included it as a full-throated conclusion in a Leonardo catalog he wrote.

Houssaye was both absurd and spectacular. He wrote incessantly, though not substantially: poems, semi-historical satirical sketches, literary and art criticism, sto-

ries of various kinds, one-act plays, articles on art and history, along with the prefaces of other people's books. It would not be a surprise if opium, absinthe, and copious amounts of alcohol explained his wan appearance. Equally likely is that cocaine course corrected his metabolism with adrenaline jolts that hurled him from one thing to another, for he managed to participate in virtually every artistic outlet Paris had to offer. His frenetic accomplishments placed him simultaneously as editor and proprietor of *La Presse,* and at another time he ran the administration of the Théâtre-Français. To be sure, one of his initiatives would lay claim to something that bedevils the experts to this day.

LIKE THE CZARTORYSKIS, the noble Dzialynskis were forced to emigrate after the collapse of Poland's November Uprising. They, too, had their estate and holdings confiscated. They, too, settled in Paris, which is how and where Count Jan Dzialynski met and married Wladyslaw's sister.

Jan Dzialynski had been a Polish activist who, refusing to limit himself to persuasion by debate, developed the prototype of the Polish multi-shot repeating rifle. It was only after the Prussian authorities granted amnesty to Jan that the Dzialynskis felt it safe enough to return to their estate in the Prussian partition. Due to the fact that the Dzialynski estate had an extensive library and a designated librarian, Wladyslaw transferred the better part of the Czartoryski archives there from the Hôtel Lambert.

Though the issue of Poland's return to its previous status as an independent entity had been removed from the European agenda, Prince Wladyslaw remained determined to reinstate his grandmother's wish for a public museum on Polish soil. There was but one option available to him:

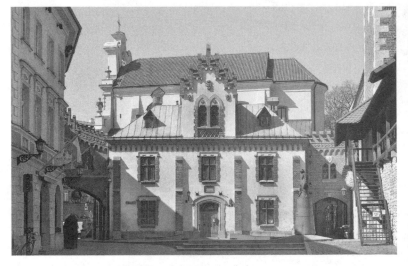

*Princess Izabela Czartoryska's museum,
converted from Kraków's fifteenth-century arsenal that had once
stored the city's cannons and gunpowder.*

the only partitioned part of Poland allowing Polish culture to flourish belonged to the Austro-Hungarian Empire. At its center was Kraków, and in 1874 the city offered its arsenal as a permanent site for a reestablished Czartoryski museum.

Two years of renovation produced a handsome neo-Gothic building to which was moved, first, the family's consolidated archives stored in Paris and Sieniawa, then the books and portfolios waiting to be retrieved from the Dzialynski library; next were the artifacts and artworks not lost or destroyed over the previous century.

Prince Wladyslaw added to the collection with his own pictures, as well as Etruscan, Greek, Roman, and Egyptian

antiquities he had acquired, but when the museum opened to the public in 1872, a piece in the collection from which he refused to be parted was *Lady with an Ermine*.

Some four years after the portrait arrived in Kraków by way of Vienna, it was still sequestered in Wladyslaw's private apartments and seen only by a limited number of people outside his family: one of those fortunate few was Wilhelm von Bode, the first curator of Berlin's Kaiser Friedrich Museum (now called the Bode Museum). His opinions on Italian Renaissance art were extremely influential, and his widely distributed article praising the qualities of *Lady with an Ermine* brought the portrait to the attention of museums and dealers for the first time.

Only when the Austro-Hungarian government formally approved the ordinance for the museum did Wladyslaw agree to remove *Lady with an Ermine* from the wall in his private apartments. He died in 1894. His son Adam Ludwik became the head of the Czartoryski family and the museum.

Adam Ludwik was a major winner in the lottery of inheritance. When, at his father's death, he was moved to the head of the family, he became the owner of its collection and *ordynat* of the Sieniawa property. Shortly after, his aunt bequeathed him her own art collection. When his brother predeceased him, that inheritance came to him as well. Despite these sizable windfalls, it was Adam Ludwik's marriage to Countess Maria Ludwika Krasińska that became the engine which would motor the Czartoryskis' financially weaker estates and save the Czartoryskis' legacy.

*Seen here as almost secondary to her hat
is Countess Maria Ludwika Krasińska. Her shyness was deceiving.*

Ludwika was an only child in a family whose eye-watering fortune came from a combination of sugar plants, mills, racehorses, and income-producing properties, including several grand estates. She was young when her father died, and because she was his only heir, circumstances necessitated the kind of husband who would understand what would be required to manage her vast inheritance and the properties that came with it. At eighteen, she was married to Prince Adam Ludwik. She, too, became a significant collector of art, and by contributing her inherited historical memorabilia, along with the works of art she acquired on her own, she brought the combined

family collections to some five thousand paintings, antiquities, and porcelain.

————

Like other Poles from the generation of patriots following the November Uprising, Józef Korzeniowski was a child when his family immigrated to England. As a young man, he changed his name to Joseph Conrad, settled in London, and established a successful career as a writer. So little attention did Conrad pay to the assassination in 1914 of Archduke Franz Ferdinand, the successor to the imperial Austro-Hungarian throne, that shortly after the event he took his wife and children on a continental holiday to Kraków to see the city of his birth. Upon arriving, they discovered that they were in the enemy territory of Austria-Hungary and barely managed a safe return to London.

Benefiting from the wisdom of hindsight, historians now suggest that World War I was foreordained, that the political instability in Europe could be felt from the various alliances grinding against one another like tectonic plates. But Conrad's dismay when war was declared—as well as the sense of the obliqueness of its reason to begin with—was shared by countless others.

When Austria shifted to a war footing and Adam Ludwik joined its military as an officer, it was the diminutive but disciplined Ludwika who took charge of the Czartoryski Museum's direction. Between 1914 and 1918, a global assembly of two opposing alliances led to unprecedented death and destruction. Britons called it the Great War.

During its first year, soldiers didn't have the protection of metal helmets, and the only defense against gas attack were cloths soaked in their own urine. Six weeks was the average life expectancy in the trenches.

During four years that bled away the lives of some forty million people, Ludwika and her children were living in Dresden, the capital of Saxony in eastern Germany and a city suffering no damage. By relying on the Czartoryskis' connections to the royal Saxon family, Ludwika was able to transfer the most valuable objects from the palace in Kórnik and the museum in Kraków to Dresden's Royal Collections, having agreed that *Lady with an Ermine* could be seen by visitors on certain days. To prevent any misunderstanding of ownership, a seal was nailed on the left-hand side of the back of its frame indicating that it was the property of "*Furstluch Czertoryskiches Majorat Gluchuw.*"

Monitoring all of this at close range was Hans Posse, a protégé of Wilhelm von Bode's and one of a handful of people outside the Czartoryski family who had seen *Lady with an Ermine* before its public debut in the Czartoryski Museum in Kraków.

Vigilant curator that he was, Posse took it upon himself to include the portrait in Dresden's 1915 Royal Collection Exhibition. In the exhibit's catalog, he correctly identified Cecilia Gallerani as the portrait's subject, and a certain solace could be found in that, but in the years to come, none would be found in Posse's mendacious character.

Russia was drastically altered by the war: the tsar was overthrown; a provisional republic was established and then toppled by Lenin. The war reshaped Prussia and

Austria as well—the two other states, which, decades before, were responsible for partitioning Poland. All three nations met their demise through either defeat or collapse, and from their combined failure came the reemergence of Poland's independence. Hans Posse's greed fed on the disorder. Ludwika spent two long years negotiating with him for *Lady with an Ermine* to be united with the other works of art in the Czartoryski Museum. This didn't mean that Hans Posse's interest in the picture receded. The opposite. With Hitler's creation of a new Germany, *Lady with an Ermine* was placed within reach of Posse's grasping ambition.

PART THREE

––––––––––––––––––––––––––––––––––––

Hidden in advance of the German invasion

of Poland, discovered by the Gestapo,

fought over by high-ranking Nazis,

the portrait is transported

to Berlin and then returned to Poland,

where it bears witness to one of history's

most immoral undertakings.

––––––––––––––––––––––––––––––––––––

TWENTY-ONE

"THE FÜHRER LOVES ART because he himself is an artist," so said Joseph Goebbels in an assertion that was very much in line with his role as Nazi Germany's minister of propaganda. In fact, the only person who considered Hitler an artist was Hitler. That was the case when, at eighteen and after failing a formal education, he applied to the Academy of Fine Arts in Vienna in 1907. That was still the case when the academy denied him admission after his work was deemed inadequate by jurors whom he believed were Jews. That remained the case when he moved to Germany, where he was barely able to support himself by selling his paintings and watercolors as cheap souvenirs.

It was in Berlin that Hitler joined the German Workers' Party, a small group of extreme nationalists, and where he realized that his true talent lay in an ability to command public attention. The release of *Mein Kampf* added support to his leadership position within the renamed National Socialist German Workers' Party. Due largely to his political acuity and mesmerizing speeches, the party's

non-majority status was converted into an effective governing power. As the newly installed German chancellor a decade later, Hitler made a point of visiting museums in Venice, Florence, and Rome. He came to believe that to consolidate political power in Germany, he needed to control its culture. By 1933, he had decided that all forms of art should be subordinated to the regime. When he ordered that Germany's museum directors become employees of the state, Goebbels reinforced the decree by establishing an entity whose membership was mandatory for anyone in the arts. Nonmembers could neither create nor sell art. Jews were denied membership altogether.

Convinced that art, race, and politics were closely bound, Hitler aspired to be the ultimate representation of Nazi ideology and a supreme art patron. Germany's flooded art market made more and more art attainable to him: initially, royalties from *Mein Kampf* paid for his collection; nurturing its growth was a surtax on the postage stamp that featured his image. His preference in pictures pointed toward the old masters, which he considered an acknowledgment of cultural sophistication. He enlisted the services of well-established art advisers, most of whom had international contacts. At least one had an office in London.

Collecting art at an equally impressive rate was Hermann Göring, who, after being named minister without portfolio in Hitler's new government, created the Gestapo. By utilizing its manpower, Göring was able to become one of the Nazis' biggest beneficiaries of looted art, the magnitude of which was made evident by the hundreds of pictures that hung on the walls of his estates. Like Hitler,

he was particularly keen on the old masters—especially the Italians.

Exponentially enhancing the collections of both men was what happened in the early hours of March 12, 1938. When German forces crossed into Austria, it created an intersection of Nazi assertion and personal enrichment. The SS wasted no time in confiscating valuable art left behind by prominent Jewish families who fled in advance.* Orders to seal Austria's border came from Göring. Jews remaining in Vienna were required to register their properties with his Gestapo. This provided an excellent inventory system and starting-off point for premeditated opportunities to steal. It would continue without interruption for the next six years.

Göring was not the only Nazi in Vienna carting away confiscated art objects. The possession of valuable art had become a status symbol among the upper echelons of the Nazi Party: senior members of the SS, along with Germany's Reich Chamber of Culture, decked themselves out with it. When Hitler became aware of the growing number of German officers prowling the bulging storerooms, he issued a third-person pronouncement: "The Führer reserves the right for himself the decision as to the disposition of art objects which have been, or will be, confiscated by German authorities in territories occupied by Germany."

Fancying himself an architect as well as an artist, Hitler

* Among the confiscated pictures in Vienna were some by Gustav Klimt, who had often been commissioned to paint the women in wealthy Jewish families. Those portraits were reassigned generic names, such as *The Woman in Gold,* and most of their subjects perished in the Holocaust.

had for years drawn sketches of a museum he envisioned in his hometown of Linz. The Führermuseum would feature European masterpieces and confirm the superiority of Nazi Germany. Linz would surpass the glory of Vienna— the city that humiliated him in his youth. Those were Hitler's plans. Implementing them required an organized system of controlling the confiscation of art, along with a selection process to choose the most desirable pieces from the stolen trove.

In July 1939, Hitler summoned Hans Posse—the very man who, at the end of World War I, attempted to delay *Lady with an Ermine*'s return to the Czartoryski Museum in Kraków from what was meant to be only a temporary refuge in Dresden. Posse was instructed to commence the Führermuseum project by supplementing Hitler's personal collection with works of art obtained through purchase or confiscation.

Hans Posse was far from the only exemplar that intelligence and intellect do not insulate against immorality; countless other art experts became implacable participants in Germany's organized plundering. It wasn't just museum officials and dealers but also distinguished scholars and academics who took advantage of opportunities to appropriate and transfer entire libraries. Seeking to defend the indefensible, they might have persuaded themselves that it was the least bad of the options available, and after weighing the rewards against the consequences of withholding their cooperation, they chose to be part of a well-oiled business that would loot Europe's cultural artifacts, its artworks, its libraries—its very culture.

Hans Posse was a distinguished art historian who had been the director of the Royal Collection before being named the director of Dresden's Saxon Central State Archive. He helped to create the most extensive and thorough criminal enterprise of looting European art.

The day following his meeting with Posse, Hitler set up what was to be called his "Special Commission" in Dresden, and he publicly authorized Posse to "build a new museum for Linz," instructing that "all Party and government offices are obliged to support Dr. Posse with the completion of this order." It was at this point that there ceased to be a distinction between artworks Posse would identify for Hitler's collection and those meant for Hitler's museum in Linz.

Posse's first inspection tour began in Munich, where he selected pictures from a central depot that housed the confiscated property of German Jews. From there, he

continued to Vienna, where he sifted through some eight thousand pieces stored in another depot. Proving himself an energetic archivist, he kept meticulous records in his notebooks and travel diaries of what would become the institutional plunder of one-fifth of Europe's artistic patrimony.

DURING THE TWO CENTURIES that fate seemed intent on placing *Lady with an Ermine* in repeated danger, it was often a woman who rescued it.

Adam Ludwik died in 1937, in the midst of the growing Nazi threat. His oldest son, Prince Augustyn Czartoryski, became the heir of the family's properties, but it was Ludwika who had a hand in the logistics of protecting the family's combined collections, just as she had during World War I.

Sandbags were placed around the Czartoryski Museum. First-aid kits and gas masks were issued to the staff, along with instructions to protect the most precious objects. Selected pieces of gold, gems, illuminated manuscripts, and thirty-one paintings were placed in sixteen crates. The remaining items were carried down to the museum's cellars. Three other paintings were gently removed from their frames and packed in a separate wooden case marked "LRR," signifying Leonardo, Raphael, and Rembrandt. The wooden case and sixteen crates were transported by truck from Kraków to the Czartoryski agricultural estate

in Sieniawa—the same estate where, during Poland's November Uprising in Warsaw a century before, Prince Augustyn's great-grandmother Izabela had hidden *Lady with an Ermine*.

———

As *Lady with an Ermine* was being entombed yet again—this time in a specially prepared shelter in a cellar of one of the Sieniawa estate's outbuildings—twenty-seven-year-old Clare Hollingworth, who had recently arrived from London, was settling into her new job at the British consulate in Warsaw. Her duties were meant to be primarily secretarial, but—truth be told—she had already wandered outside that remit to have a fling with the consul general. Her unscripted adventures did not stop there. She began to secretly file emergency visa applications in order to smuggle out Austrians and Germans actively opposing Hitler. Though the Germans tried and failed to intercept Hollingworth's messages, the British Home Office realized that she was a loose cannon. Recalled to London and informed that she was being relieved of her duties, she left the Home Office building, took a taxi to Fleet Street, walked into the offices of one of the major national newspapers, and insisted on seeing the editor. After persuading him to dispatch her to Berlin as a freelance foreign correspondent, she hailed a cab to Harrods to purchase new luggage. The following morning, she took a flight to Berlin, which landed less than an hour before Hermann Göring banned all civilian flights in German airspace.

In the month or two between Hollingworth's being

recalled to London from Warsaw and the point at which she returned there as a freelance journalist, the Nazis had been busy devising a hoax of massive proportions—one that would confirm the belief held by the party's minister of propaganda, Joseph Goebbels, that "the broad mass of people falls victim to a big lie more than a small one."

Niccolò Machiavelli's observation four centuries prior was that "one who deceives will always find those who allow themselves to be deceived." Goebbels built on that theory with an understanding that the success of a regime dedicated to creating its own reality relied on more than false truths—that it must go one step further by animating lies with action. Today it's the internet. Back then, the radio was the fastest transfer of messaging to the public. With the ruse devised by Nazi officials intended to convince Polish allies that Germany was a victim of Polish aggression, the radio was the content provider and distributor.

A dozen Polish-speaking German convicts, dressed in Polish army uniforms, were transported to a German radio station on the Polish border. One of them spoke a Polish call to action against Germany into the station's microphone. Picked up and transmitted by the German broadcast system, it was all that was needed to provide Germany with the pretext to "retaliate" by mobilizing its military against what would be falsely presented to the world as Poland threatening the fatherland. Also fabricated was Germany's lightning-fast, victorious response: after playing their part in the manufactured assault, the German convicts were lined up and shot on the radio's premises by

the same German soldiers who'd brought them there only hours before.

Polish citizens woke the next morning to the incredulous news that their army had attacked the Third Reich. With no declaration of war from Germany, the British government released a statement suggesting that "the full implication of these events is not yet apparent."

Nine days before France declared war against Germany, the Parisians began an all-too-familiar process of protecting their cultural treasures from invading forces by taking down the stained-glass windows of the Sainte-Chapelle—the royal chapel within the medieval Palais de la Cité, which had been residence of the kings of France until the fourteenth century. At five o'clock that same day, the Louvre closed its doors to the public, and a small army of curators, staff members, and volunteers—aided by packers from the nearby large department stores—worked around the clock to unmount, wrap, and crate many of the world's most precious art pieces, each designated in a system of dots: two red dots were given for the highest priority of evacuation. The crates were loaded in trucks, and with their headlights turned off to observe the blackout, slow-moving convoys transported their cargo to pre-chosen locations in the Loire Valley. Included in what would be the largest museum evacuation in history were Leonardo's *La Belle Ferronnière* and the *Mona Lisa*—the only item assigned three red dots.

While the rest of the world remained in a suspended state of self-imposed ignorance about Hitler's intentions, Clare Hollingworth—two weeks on the job as a freelance journalist—reported from Warsaw on the increased ten-

*Clare Hollingworth, a young British journalist
who broke the news of Germany's invasion of Poland
with what was dubbed "the Scoop of the Century."*

sions in Europe. Having persuaded her former lover the
British consul general to lend her his diplomatic car for a
day, she discovered the buildup of German troops along
the Poland-Germany border where, when the wind gusts
blew away the camouflaged screens that were meant to
conceal German tanks, she could see a vast armament fac-
ing Poland.

The next day, Hollingworth phoned the British em-
bassy in Warsaw to report that Germany was invading
Poland. Embassy officials expressed doubt, and she held
the telephone out her hotel room window for them to
hear the sound of artillery fire. By then, 1.5 million Ger-
man soldiers, more than two thousand airplanes, and some
twenty-five hundred tanks had already crossed Poland's
border.

IN A PREEMPTIVE MILITARY STRIKE coming from nowhere and everywhere all at once, Germany's blitzkrieg was over before anyone understood what had happened. Two days later, Britain and France declared war on Germany. The Soviet Union—also without a declaration of war—attacked Poland from the west. Hitler and Stalin agreed to their respective spheres, and yet again Poland was partitioned. The larger Soviet zone was incorporated into the Soviet Union. Germany's take was merged into the Reich, and the 30 percent remainder of what had been Poland was designated as the General Government. Its administrative headquarters was situated in Kraków, which would be transformed into a German colony with German the only language spoken. Hans Frank was installed to act as Hitler's representative there as the critically important governor-general, charged with the expansion of Germany's territorial base.

Frank's face was anything but elegant. It featured eyes the color of black licorice and a coarse nose that drew

attention to itself. His thinning jet-black hair was habitually slicked back from a wide forehead that seemed always to have a slight film of sweat on it. Dark complexioned and with a clammy constitution, he could never claim to be Hitler's ideal specimen of a superior race, but how the Holocaust became possible lay in large part with two less visible but far more relevant qualifications Frank possessed: impressive administrative skills and an intuitive understanding of industrialization.

Frank would rule from behind a desk in Kraków's Wawel Royal Castle, the official residence of Polish monarchs since the fourteenth century. Surrounded with beautiful art, he would champion the Nazis' vision of racial

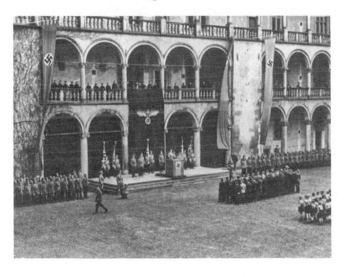

Wawel Royal Castle—located off Kraków's central square— became the residence and offices of the German governor-general, Hans Michael Frank. Its impressive Romanesque architectural style set the stage for Nazi aggrandizement.

purity. The wealthy in a position to leave Poland were forced to do so immediately and found themselves at the mercy of retainers who, for a fee, offered to move their valuables to safety in the West. No guarantees were had: the Radziwiłłs trusted a man representing himself as a Dutch diplomat who volunteered to protect the family's priceless jewelry collection and sold it. Before escaping from Kraków in a Swiss Red Cross truck, they managed to recover a diamond and emerald tiara, which paid for the purchase of a house in London.

As a self-proclaimed lover of art, Frank was delighted to find himself in a position to choose from the Wawel Royal Castle's collection while decorating his private apartments and suite of offices. But the one picture he coveted was not at his disposal, and as it happened, there were two other high-ranking officials also after it: Hans Posse, acting on behalf of Hitler; and Kajetan Mühlmann, an Austrian art historian and SS officer who—when Poland was made Germany's creature—had accepted a position offered by Göring as special delegate for the securing of artistic treasures in the former Polish territories. By then, Göring's obsession with acquiring art was often distracting him from his command.

Despite Göring's reminders to Mühlmann that it was he to whom Mühlmann owed his allegiance, Mühlmann made a point of establishing a direct channel of communication with Hitler by providing him with five volumes of photograph albums of designated artworks, some of which had yet to be located, much less confiscated. One was *Lady with an Ermine*.

Having cut his teeth by confiscating art in his native Austria, Mühlmann was well positioned to devise a highly efficient system of looting. He assembled a staff in Poland that comprised nine art experts—eight of whom had doctorates—along with two commandos, each with a squad of a dozen men and trucks to transport seized items. The squad responsible for northern Poland was based in the Warsaw Museum; the other, based at the library of one of the oldest universities in Europe, Kraków's Jagiellonian University, was assigned southern Poland. By working outward from their separate headquarters, they emptied the country of its state and private collections while Mühlmann shuttled between the two, cataloging what had been stolen. He ranked the art in three grades: pictures and objects of the first grade were photographed and reserved for the German Reich; those that fell into the second grade were classified as "not worthy of the Reich, but of good quality," and either stored in Poland (primarily in the Jagiellonian Library) or transported to Berlin to be held by the Deutsche Bank; works of the third grade were retained by the occupation administration or the SS "for representational purposes" in German homes and offices.

Perhaps ambition overtook him, or it might have been that he felt pressured by an ever-increasing number of Nazi leaders expecting him to provide them with artworks. Regardless of the motivating factors, under Mühlmann's management almost all of the precious artworks that had filled the whole of invaded Europe had been pillaged by the end of the war.

While *Lady with an Ermine* continued to appear on top

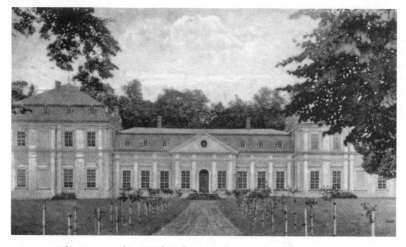

The Czartoryski agricultural estate in Sieniawa, where the portrait was bricked up in the wall of an outbuilding.

of Mühlmann's "to locate" list, Providence prevented it from being found in Sieniawa, from where Augustyn and his wife—pregnant with their first child—fled the family estate and took refuge at Augustyn's cousin's residence in the Pelkinie Palace, ten miles south.

The only person who remained in the Sieniawa palace was a housekeeper by the name of Zofia Szmit. She could hear the sound of muffled gunshots in the distance. First came the retreating Polish troops. Next, the German horse and car units, which moved on. A day later, a German troop arrived and took up quarters on the estate. They stayed for three days.

The museum's decision to transport artwork to the estate had happened in absolute secret. Zofia had no knowledge that *Lady with an Ermine*—along with the museum's other

valuable pieces—was on the premises. After the German soldiers left, she discovered the damaged door to one of the outbuildings. Inside, the vaults containing some part of the Czartoryski collection had been demolished, and all sixteen crates had been broken apart. Objects were scattered on the ground. The wooden chest containing the pictures by Leonardo, Raphael, and Rembrandt was pried open. The German troops had taken the more transportable objects—a set of famous twelfth- to sixteenth-century Limoges enamels, various relics and coins, and a number of engravings by Dürer—and *Lady with an Ermine* had been carelessly yanked out of its case. Zofia found it leaning against a wall with a boot mark on it.

The Nazis considered Poles *Untermenschen* (inferiors), and drilled into Hitler's military leaders were orders to "kill without pity or mercy all men, women and children of Polish descent or language in the invasion and extermination of Poland."

Zofia Szmit, a Polish housekeeper whose undeterred bravery saved Lady with an Ermine.

Warned about the arrival of more German forces, Zofia had reason to fear for her life, but while most in the village took shelter in the outlying forests, she enlisted the help of another woman who had also stayed behind. The two women cleaned the boot mark off *Lady with an Ermine* and fashioned a protective cover for it by sewing together two pillowcases. Guarding the portrait with their lives, they managed to keep it safe until Augustyn Czartoryski could make the perilous return to Sieniawa from Pelkinie and retrieve it before the next wave of German soldiers arrived or, just as likely, members of Russia's Red Army, who had free rein in that part of Poland.

No matter how often, or where, *Lady with an Ermine* was concealed, Posse and Mühlmann were equally determined that it be found. Eventually it was located by the regional Gestapo at the Pelkinie Palace. Advised of this, Mühlmann ordered the curator at the Czartoryski Museum—a man who had dutifully carried on in Kraków and protected what had been stored in the museum's basement—to accompany him to Pelkinie. When they arrived there, they were informed that the Gestapo had taken the case with the three masterpieces to the city of Rzeszów. Mühlmann and the museum curator traveled there to reclaim the painting, whereupon arrangements were made to transfer it to the Jagiellonian Library in Kraków. The curator—having served his purpose—was arrested and sent to a concentration camp.

From Kraków, *Lady with an Ermine* was put on a train, along with other artworks from the Czartoryski Museum, and sent to Warsaw, where it lingered only as long as was necessary for officials to fill out paperwork. From Warsaw,

it continued to Dresden, where waiting on the platform at the train station was Hans Posse.

After inspecting the haul from the Czartoryski Museum that had been hidden in the Sieniawa estate—as well as the looted artworks from the Pelkinie Palace—Posse chose the pieces he would add to the führer's personal collection and those destined for the Führermuseum. He decided that *Lady with an Ermine* should be transferred to Berlin for safekeeping.

Time and again, the portrait had managed to sidestep disaster, but it would be a mistake to overlook the workings of chance. Had *Lady with an Ermine* remained in Dresden, in all likelihood it would have perished during the final month of the war with the British-American aerial bombing that dropped four thousand tons of high-explosive bombs and incendiary devices on the city over three consecutive days.

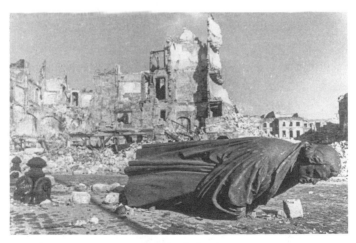

Dresden after firebombing.

OPERATING UNDER THE IMPRESSION that when it arrived in Berlin, *Lady with an Ermine* would belong to him and him alone, Göring instructed Mühlmann to waste no time transporting it from the Berlin train station to the Kaiser Friedrich Museum, where he would be waiting for it.

Hans Posse had every reason to believe that at some point he would be organizing the portrait's transport from Berlin to the Führermuseum in Linz, Austria, where it would confirm the Reich's superiority and position Hitler in history as he would want. As for Hans Frank, he was hoping that it might take a different route, or at least a more circuitous one. Frank had lobbied Hitler to allow the portrait to return to Kraków for the time Frank would be stationed there as Poland's governor-general.

More important to Hitler than Frank's interest in *Lady with an Ermine* was Frank's reputation within the Nazi Party as a professional technocrat, eager to prove his worth. When Hitler described his objective in Poland to Frank, he likened it to cutting up a cake: "We now have

to face the task of cutting up the cake according to our needs in order to be able: first, to dominate it; second, to administer it; third, to exploit it."

As an acknowledgment of just how much would be expected of Frank, Hitler consented to what he considered Frank's relatively minor request of temporary ownership of *Lady with an Ermine*.

———————

During the some four hundred years preceding Germany's occupation of Poland, *Lady with an Ermine* survived epidemics, fires, floods, greed, theft, ancient grudges, retribution, and bombing. It had been spirited away in a horse's saddlebag and traveled by carriage, possibly by boat, certainly by truck and car during dangerous nocturnal escapes. During a winter's afternoon in 1939, it was found safely secured on a seat in the first-class cabin of a train traveling from Berlin to Kraków. Sitting next to it was Kajetan Mühlmann, ordered by Hitler to bring the portrait back to Kraków, where Frank would be allowed to hang it above his desk until the Führermuseum could be built.

Göring was bitterly disappointed by Hitler's decision. Hans Frank could not have been more pleased.

Like Göring, Mühlmann, Posse, and the German museum directors eager to fill their institutions with stolen art, Frank thought of himself as a civilized man. He was certainly educated, a reader of Shakespeare, and able to recite Goethe. Frank appreciated music and admired Richard Strauss, despite Strauss's Jewish daughter-in-law.

In his post as governor-general, Frank proposed cultural projects, one being a German theater in which would be staged several operas a week. He offered a room in the castle as a venue to choose actors and opera singers for this enterprise. The statue of Chopin in Warsaw had been the first public monument to be destroyed by the Nazis, but Frank ensured that the General Government would have a philharmonic orchestra and ordered that the undertaking be strengthened with Polish musicians from former orchestras.

Yes, thought Frank, *I am a civilized man.*

If what Aleksandr Solzhenitsyn wrote is true, that "the line separating good and evil passes not through states, nor between classes, nor between political parties either—but right through every human," it would also be true that evil among humankind is not rooted in circumstance, that it is an entirely separate force.

Frank devised a systematic campaign to eradicate Polish culture, the aim of which was to break national consciousness. Libraries and art collections—both private and public—were looted. In total, some seventy-five thousand manuscripts, twenty-five thousand maps, and ninety thousand books (including more than twenty thousand printed before 1800) were identified as pillars of Polish culture and destroyed. Street names were changed and monuments blown up. Singled out were professors at the University of Kraków—a bastion of Polish culture for more than five hundred years. They were taken first to prison, where they were tortured, and then to German concentration camps, where they were killed. Next were lawyers, civil servants,

doctors, businessmen, and clergy. Anyone with influence was summarily shot, some 300,000. In Frank's experimental laboratory for Hitler's New World Order, Polish Jews died in overwhelming numbers: 90 percent of the Jewish population in Poland were murdered, in all almost 3 million, with well over 1 million in Auschwitz alone.

Frank settled into a stolen castle in a stolen country and threw himself at the challenge of annihilating its Jewish population by making the process his own. His personal diaries revealed no overt signs of anti-Semitism, but as a self-serving careerist Frank did what was called for.

"The correct use of propaganda is a true art . . . that must confine itself to a few points and repeat them over and over," wrote Hitler in *Mein Kampf*. A few years later, a cable to Washington, D.C., from the counselor at the U.S. embassy in Stalin's Moscow would note that "it is possible to make [people] believe practically anything." No matter how untrue something might be, he wrote, "for the people who believe it, it becomes true. It attains validity and all the powers of truth." Hitler's definition of Jews as Germany's foes was an obvious falsehood, but repeated countless times, the fictionalization would cross into reality, carried on the shoulders of *Lügenpresse*—which, in English, translates to "fake news."

Under Frank's orders, Jews in Poland were rounded up in the villages and burned to death in their wooden synagogues. Others were herded into ghettos. When starvation and disease didn't take their toll fast enough, there was mass transportation to extermination camps. By 1942 in Warsaw, the rate of deportation to Treblinka reached

ten thousand daily. All of the camps practiced the rule of collective responsibility: for every attempt at escape, several times as many inmates were executed, creating a moral dilemma for those who might consider attempting it in the future.

Frank was brought up a Catholic. He was a husband and the father of five children. Nazism was not his invention, and he reminded himself that he had no responsibility for it, only for the success of its implementation. The wanton killing of 700 university professors, 16,500 schoolchildren, 5,000 medical doctors attempting in vain to keep their fellow Poles alive—he believed that none of this was his fault, even though he acted as architect. As for the extermination of Jewish citizens, Frank simply followed his führer's instructions: Jews were guilty of being Jews; Nazi doctrine declared their destruction inevitable. He devised the transport system that delivered men, women, and children to the gates of concentration camps whose sole purpose was to kill them once they arrived, but Frank absolved himself by insisting that he himself had never killed, that he had served only as a facilitator.

"A portal to a hideous other dimension where depravity and sadism thrived, where people were starved and tortured, and where atrocities became an unremarkable part of the daily routine" is how a survivor of the uniquely hellish universe that was a Nazi concentration camp described it. "Unimagined" is the word most often used, but it was imagined, and Hans Frank made it reality.

WHEN THE GESTAPO located *Lady with an Ermine* at Czartoryski's Pelkinie Palace, they also discovered Prince Augustyn and his wife there. The royalty of Augustyn's wife, Princess Dolores Victoria Maria de las Mercedes de Borbon y Orleans, enabled them a safe passage to Spain. Prince Augustyn's mother, Ludwika, had been in the eastern region of Poland when war broke out, after which she relocated her family to a property in Warsaw not yet confiscated and remained in contact with the museum's personnel, who converted the museum's storeroom of curiosities into a meeting place for the underground Home Army. In 1944, her youngest son, Ludwik, joined Poland's Home Army. He died at the age of seventeen fighting German troops in the Warsaw Uprising. Whatever was left of Poland's government by then had reestablished itself in London, and all the while guerrilla soldiers of the Polish resistance reassembled in the dense, primeval forests of their occupied nation.

The war remained at a distance for the French until May 1939, when Hitler launched his offensive on their country,

and German forces almost immediately defeated its army. After the surrender of France, Germany's sole remaining enemy lay across the English Channel, where Charles de Gaulle had already escaped to London and moved into a Mayfair flat located a few short blocks from that of Adam Czartoryski and his family's house when, in the previous century, they, too, had fled Paris in advance of German troops.

Twenty-four hours after the Nazis marched into Paris and hung a swastika flag from the arch, de Gaulle made a clarion appeal to the French on a BBC broadcast that "whatever happens, the flame of French resistance must not and shall not die."

Because Hitler didn't consider the French *Untermenschen* (he paid homage to Napoleon by a visit to his tomb at Les Invalides), life in Paris remained relatively unchanged, initially at any rate. Served by waiters in their traditional short vests and white aprons, Wallis Simpson continued to lunch at the Ritz hotel. The famous auction house Hôtel Drouot enjoyed its most profitable year. Making out especially well were individual art collectors, including Peggy Guggenheim, whose declared intention was to "buy a painting a day." Something else was occurring on a daily basis—the arrival of Nazi-confiscated artwork at the Jeu de Paume museum, which had been designated by the Nazis as a central storage and sorting depot. German officials there, preoccupied with the sheer volume of art arriving, paid little attention to Rose Valland, an unassuming-looking art historian who had remained on the premises. She was considered an insignificant French functionary.

Rose Valland went largely unnoticed amid the never-ending number of confiscated artworks arriving at the Jeu de Paume. She didn't look like anyone's ideal of a hero, but a hero she most certainly was.

She was, in fact, a spy.

By keeping secret her fluency in German, Valland was able to take notes on each incoming item, recording details of its rightful owner, the transport method by which it left the museum, and its ultimate destination.

To handle the unremitting arrival of stolen art, the director of the Jeu de Paume organized regular exhibits of newly confiscated items for a select number of Nazi officials. Göring—whose evil was interspersed with upper-middle-class ambition to acquire—made a point of visiting the museum on no fewer than twenty occasions. All told, he chose 594 pictures, which were transported to his sprawling country estate north of Berlin on a special train run by the Luftwaffe.

For four treacherous years, Rose Valland risked her life recording the details of some twenty thousand looted pic-

tures and objects that arrived at—and departed from—the Jeu de Paume. She continued to risk her life each time she provided information to the French Resistance on railroad shipments so that the trains containing looted art would not be mistakenly blown up. The art and objects taken from the homes of Jews in Paris alone filled some 29,436 German railroad cars—the result of some fifty thousand Parisian Jews deported and murdered, many of whom had been denounced by their neighbors.

When not housed in various museums, art looted by the Germans was stored in hundreds of other repositories from which Hans Posse could pick and choose. *Lady with an Ermine* had not been officially designated for the Führermuseum, but Posse never doubted that Hans Frank would return the portrait after the Reich's victory. The war began to take a turn against those plans when Nazi Germany—having already confronted Allied forces in the west—attacked the Soviet Union in the east. Hitler had overreached. Russia's immense territory allowed plenty of room to retreat and regroup. As for invading forces, every mile gained forced them to extend their supply lines, which became increasingly vulnerable. When the Nazi high command ordered German troops to live off the land, the Russian people did what their ancestors did when they resisted Napoleon some 130 years before: they destroyed their own crops and burned their villages, thus denying the German soldiers sustenance and shelter. The result engulfed Germany in the hopelessness of a two-front war: from the east, the Army of Red Guards pushed farther into Poland; in the west, Dresden was firebombed by the Allies.

*Hitler's personal collection and that of the Führermuseum were taken
to a safe refuge in the east, while countless envoys of trucks, swollen
with the Reich's confiscated art, made their way to a fashionable resort area
high in the mountains, southwest of Salzburg, that provided storage in
labyrinthine networks of deep salt mines.*

Fearing that Dresden was only the beginning of an organized campaign of terror strikes against Germany, museum directors in Berlin drew up plans to protect their own artworks and to safeguard those stolen pieces stored in museum buildings.

"The tree falls and the monkeys scatter." So goes an ancient Chinese saying.

In the spring of 1944, after learning that Soviet forces were advancing in eastern Poland, Hans Frank prepared to evacuate the Wawel Royal Castle, and with no intention of leaving empty-handed, he made arrangements for *Lady with an Ermine* to be transported to the palace of an associate in a former Prussian province. From there it was

moved to Frank's summer villa in Bavaria, just south of Munich. Despite the lack of packing materials, miraculously, the portrait wasn't damaged by the hazardous road conditions and arrived safely in Bavaria.

Rose Valland's journals proved to be veritable guidebooks to Nazi plunder in France; no other individual had protected as many works of confiscated art. But General Dwight D. Eisenhower is rightfully credited for what would become the formation of a team of a dozen American museum curators, architects, and archivists who joined combat operations in still-German-occupied European countries in order to protect cultural property from—and damage by—the Allied forces. In a letter sent to his field commanders before the Normandy invasion, Eisenhower conveyed his instructions in no uncertain terms: "Shortly we will be fighting our way across the Continent of Europe . . . Inevitably, in the path of our advance will be found historical monuments and cultural centers which symbolize to the world all that we are fighting to preserve. It is the responsibility of every commander to protect and respect these symbols whenever possible."

With meager resources and virtually no means of transport, a handful of noncombatants hustled their way to the front lines to prevent damage to monuments, artworks, and libraries. The group of twelve, later joined by British, French, and Dutch experts, become known as the MFAA, Monuments, Fine Arts, and Archives Section, a civil division of the Western Allied armies. Dubbed the Monuments

Men, they retrieved some five millions objects—retrieval increasingly becoming the primary goal.

In the last gasp of the war, Rose Valland's assiduous record keeping was finally given its due by the Monuments Men when the notes she took on Hermann Göring's visits to the Jeu de Paume led them to his country home near Berlin, where they discovered his handwritten catalog of some fourteen hundred works of art stolen from Jewish owners. Other details in her notebooks pointed to Neuschwanstein, a remote castle in Germany, which housed the art and furniture from the prominent collections of, among others, the Rothschilds.

No longer the master of his territory, Frank pressed ahead to set up a chancellery for Germany's government in Poland in a small hotel in a Bavarian resort town not far from his villa. Shortly after arriving, he had a surprise visit from the general director of the Bavarian State Museums, who conveyed Hitler's order that *Lady with an Ermine* be transported to a secret location. Someone would come to retrieve the painting, he was told. But days passed without anyone showing up. Hitler and his retinue had already installed themselves in the Führerbunker, where, with his Thousand-Year Reich in shambles, he issued instructions in a memo. "Destructive Measures on Reich Territory" (nicknamed the *Nero Decree,* after the emperor who presided over Rome while it was burning) were orders to obliterate German industry, its infrastructure, and "anything of value." This included the plundered art.

Eight bombs were placed in the tunnels of an extensive complex of salt mines in the Austrian spa town of

*Neuschwanstein Castle, a nineteenth-century Romanesque Revival palace
commissioned by the mad king Ludwig II of Bavaria as a retreat,
became one of the many properties the Nazis used to warehouse what
they had stolen. It took more than a year to identify and
remove all of the looted items there.*

Altaussee serving as repository of those masterpieces that
had been designated as focal points for Hitler's future Füh-
rermuseum. Had it not been for the arrival of the Ameri-
can troops that disarmed the explosives, Michelangelo's
Madonna of Bruges, Jan van Eyck's Ghent Altarpiece, and
Vermeer's *Astronomer* would have been among the master-
pieces burned to the ground. And had *Lady with an Ermine*
been transported there from Hans Frank's Bavarian house,
as Hitler had ordered, it would have been among them.

Stein is a common German-Jewish surname, derived from the German word *Stein,* which means "stone" or "rock." An enduring justice is rooted in the fact that it was a Lieutenant Stein of the U.S. Seventh Army unit who arrested Hans Frank on May 4, 1945.

While the established policy of the major Western allies was to return confiscated items to the countries from whence they were stolen, Soviet authorities had no qualms claiming that Nazi loot and German-owned work were justifiable retribution for the losses Russia suffered. At the end of the war in 1945, more than two and a half million works of art and some twelve million books were seized by a special Soviet division known as the Trophy Brigade. If it had been Russian troops, and not the American army, that captured Hans Frank, *Lady with an Ermine* would have undoubtedly been considered by the Soviet leadership a form of compensation for the loss of life caused by the Nazis and the damage they caused to Russia's cultural heritage. Equally likely would have been its destination—the Hermitage Museum in St. Petersburg.

PART FOUR

Rescued from a depot in Munich,

the portrait is warehoused in Poland under

Stalin's Communist reign; it is flown to Moscow

under Soviet orders; and at the end of the Cold War

it is seen for the first time in the West.

THE END OF WORLD WAR II brought with it the debate on how to hold Nazi leadership accountable. The British government proposed the direct course of shooting the German high command as soon as its members were formally identified, and the U.S. State Department was leery about the prospect of trying war criminals. It fell to William J. Donovan, an American lawyer turned diplomat and best known for heading the OSS (the precursor of the CIA), to collect evidence and identify witnesses before Roosevelt could see his way to an international military tribunal. The agreement made was predicated on the main parties accepting terms from the Soviets that the trial would be limited to Axis aggression so that Soviet authorities could not be convicted of carving up Poland and attacking Finland.

For systematizing the murder of four million Poles, Hans Frank was found guilty of crimes against humanity. He was hanged from hastily constructed gallows in the Nuremberg prison gym. His corpse was cremated, along with nine other executed prisoners and that of Hermann

Göring, who had cheated the hangman by biting into a cyanide pill the night before. Their ashes were dumped in the nearby river.

William Donovan created the Art Looting Investigation Unit within the OSS to assist the efforts of locating the 1,050 repositories in Germany and Austria containing artworks stolen by the Nazis. Art with uncertain origins located within the American-controlled zone of Germany was taken to designated storage areas referred to as Central Collecting Points. The largest was in Munich, where the sheer number of incoming stolen artworks from Nazi depots outpaced their retrievals. It took almost a year for designated authorities to identify property stolen from their nations' institutional and private owners.

Filling twenty-seven train cars was the looted art from Poland that arrived in Munich. It was transferred to the Collecting Point, where Polish authorities were expected to oversee the process of its repatriation.

Months passed without a single designated official showing up.

It's difficult to overstate the cruel irony of the dilemma: though Poland had regained its formal independence, its government remained in exile in London. To understand the reason for this is to first know that in the near beginning of the war when German forces attacked the Soviet Union, President Roosevelt offered unconditional support to Stalin. Four years later, he made another guarantee—this one off the record—that there would be no objection if the Soviet Union absorbed Poland's eastern territory at the end of the war. In effect, Roosevelt had handed Sta-

lin an invitation to ignore the Polish government-in-exile and establish a Communist-controlled provisional government in Warsaw. Four months after the war had ended, Kraków was occupied by Russian troops.

Lady with an Ermine was left in the Munich Central Collecting Point until Karol Estreicher, a Pole in London, was made aware of its plight. Estreicher was the secretary to the Polish prime minister in exile. Before the war, he served as the head of the museum at Kraków's Jagiellonian University, where *Lady with an Ermine* had been sent after its confiscation by the Nazis at the Czartoryskis' Pelkinie estate. Stationed in London during the war, Estreicher created the Polish Office for Recovering Works of Art, a bank of covertly collected reports of stolen property sent to him by archivists, museologists, and librarians, who were still in Poland. The first of these reports arrived by secret courier in 1940 and reflected losses Poland had suffered from art stolen in 1939. The final report, in 1944, ran over five hundred pages, which Estreicher edited and published in Polish and English.

With Augustyn Czartoryski and his family living an exiled life in Spain, his control over the museum in Kraków had become tenuous. He was, however, able to designate a museum director, who, aware of the circumstances that were holding *Lady with an Ermine* hostage in Munich—along with the other artworks from the Czartoryski Museum—passed a message to London-based Estreicher.

Estreicher compiled as many details as he could before making the trip to the Munich Collecting Point. After weeks of navigating its countless rooms with their rows

of stacked artwork, he located those belonging to the Czartoryskis, including *Lady with an Ermine* and the Rembrandt picture. Missing was Raphael's *Portrait of a Young Man,* a masterpiece that—assuming it survived the chaos of the war's aftermath—has yet to be located.

Despite what *Lady with an Ermine* had been put through, it was in remarkably good condition. Estreicher noted that "only the top left corner, which was damaged before, has peeled off," adding that "it required a minor conservation treatment." He decided to put the time that portrait was waiting for restitution to good use by consulting restoration experts in Munich.

———

Named after a German artist who died the same year Germany invaded Poland, the Doerner Institute in Munich was established in 1937, inspired by Doerner's book, *The Materials of the Artist and Their Use in Painting,* which detailed his study of painting techniques. It was there that Estreicher supervised an in-depth examination of *Lady with an Ermine*.

Cradling is a restoration process that involves mounting a grid of wooden slats to the back of a painting in order to preserve the flat surface on which the picture has been painted. Because its purpose is to hold together a painting that has cracked or split over time, the procedure is often found on the back of old masters painted on wood panels.

Given the age of the cradle behind the panel on which *Lady with an Ermine* was painted, it's difficult not to believe that the small area of damage on the top left corner of the

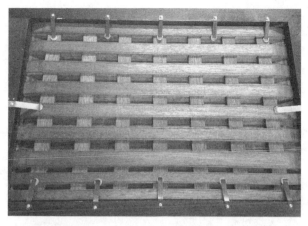

A cradle's slats are fixed to the back of the panel; secondary perpendicular slats remain deliberately loose and are held in place by the upper row—a configuration that accommodates any shift or warping suffered by the panel from the inevitable passage of time, dampness, and atmospheric pressure.

painting must have been glued onto the corner of a cradle before the painting was purchased by Prince Adam Jerzy. It's also possible that what Estreicher referred to at the time as "minor conservation treatment" at the Doerner Institute had revealed the portrait's original background blue-gray color that lay underneath. An X-ray taken at the institute hinted at the possibility that as originally depicted, a window might very well have appeared behind Cecilia.

Estreicher had lost his father and uncle to Polish concentration camps. When the time came to return the Polish-owned artwork to his homeland, he was determined to personally see it through. After spending months shepherding the disparate pieces of the Czartoryski collection through the identification process at the Munich Collect-

ing Point, he enlisted the U.S. Army to organize its train transport to Kraków. His own allegiance was made obvious by the Polish armed forces' uniform he proudly wore during the journey. Sharing his train compartment— never out of his sight—was *Lady with an Ermine*.

Circulated around the world was this photograph of Karol Estreicher holding Lady with an Ermine *at the railway station in Kraków.*

TWENTY-SEVEN

WHEN ASKED WHY she repeatedly placed her life in jeopardy for the sake of art, Rose Valland gave her opinion very decidedly. She was French, she said, and her country was obliged to save the "spiritual values it held as an internal part of its soul and culture." After testifying at the Nuremberg trials, Valland remained in Germany to assist in the retrieval of that which had been stolen from her own country and in the return of tens of thousands of looted artworks to their rightful owners.* Karol Estreicher would demonstrate the same level of commitment on behalf of his country by returning the Czartoryski collection to Kraków.

The understanding reached among the Allies was that once the train- and truckloads of Nazi-confiscated artworks arrived in the countries from which they had been

* The Louvre has created a permanent space for pictures that, to this day, remain orphaned, and in its ongoing efforts to identify the pictures' rightful owners, it encourages visitors to use their smartphones to search the Rose Valland database that it has assembled.

stolen, it would be the responsibility of those countries' governments to decide what to do with them. By the time Estreicher walked through the doors of Kraków's empty Czartoryski Museum carrying with him *Lady with an Ermine,* Stalinism had already forced aside bourgeois values for the sake of the state. It was decided that the portrait should be locked away in the museum storehouse designated for curiosities, the same room that had been used during the war as a secret meeting place for the Polish Home Army.

With German and Russian troops marching back and forth across Poland during the war, by the time it ended, the country had been decimated. Stalin's postwar agenda with what was left of Poland focused, first and foremost, on the dissemination of Soviet culture. The Polish United Workers' Party, created for that purpose, was meant to rebuild Polish institutions by incorporating ideological adjustments to a Soviet blueprint that was constructed on the theories of Marxism-Leninism. Instead, it became a jerry-rigged system that shifted, seemingly without reason, between brutalism and compromise.

A special commission on education and culture was established to reorder Polish social and cultural life to accord with what Soviet authorities identified as ideas of progress. Everything became state owned or state supervised. The private sector was all but abolished. Polish citizens became servants of the proletarian cause. Neighborhoods were replaced by a panorama of housing blocks and factories. Private property was gone. Intimacy was gone.

The former aristocracy became the least respected members of society. The Czartoryski estate in Sieniawa, which had twice hid *Lady with an Ermine* during the previous century, was deemed an unwanted legacy of nobility and deliberately set on fire so that it could be extinguished as an object of celebration on the United Workers' Party's Fireman's Day. Not as easy a target for the Communists to humiliate was the Czartoryski Museum in Kraków. Because its circumstances were complicated in ways the Soviets could not wholly control, it continued as the only private collection in Poland. Augustyn Czartoryski died of tuberculosis in Seville. His six-year-old son, Adam Karol Czartoryski, became the sole heir. Augustyn's cousin Prince Wlodzimierz assumed the custodial role of the entailed estate. Maria Ludwika Czartoryska died in exile in Cannes, France. She bequeathed the Hôtel Lambert in Paris to her heirs.*

As long as the Czartoryskis' treasures remained located outside Poland, the Polish Communist state had no legal wiggle room. If the state were to nationalize the Czartoryski Museum, it would automatically forfeit its right to reclaim any one object on foreign land, much less all of them. Circling the challenge rather than confronting it, the state—acting through the agency of the National Museum in Kraków—took into its care the Czartoryski Museum and the collection in 1949. By so doing, it was positioning itself to claim the looted items in its name at

* The Czartoryskis would eventually sell the Hôtel Lambert to Baron Guy de Rothschild.

some point in the future. In the meantime, the collection's historical or Czartoryski-related items were removed, and the museum's independent director, chosen by the Czartoryskis, was replaced by a state-assigned manager, Tadeusz Wincenty Dobrowolski.

Dobrowolski had been a doctor of philosophy in the field of art history at the Jagiellonian University until Hans Frank ordered the arrest of the university's professors. He was eventually released from a work camp and earned a living in a paint and varnish factory. At the war's end, Dobrowolski returned to the university to teach, and even after the state assigned him the role of managing the Kraków Czartoryski collection, he continued to focus his attentions on his academic interests. This was a relief to Prince Wlodzimierz, who, along with the Czartoryski curatorial staff, was deliberately keeping the collection's profile as low as possible for fear that its treasures might be cherry-picked by the National Museum in Warsaw.

Stalinism in Poland never reached the horrifying scale it had in the other Eastern European states. That said, Poland experienced its share of inflicted misery within the parameters of Stalinism, which is why there is no clear way to explain the state's decision to choose Stanisław Lorentz—a previously known activist—to head the National Museum in Warsaw.

During Hans Frank's reign as Hitler's governor-general in Poland, Poles not killed or arrested were denied education, theater, Polish-language newspapers, libraries, and

museums. In a time when Poles could be sentenced to death for owning radios and listening to Polish-language broadcasts, there were underground newspapers and opportunities for Polish artists to display their work at secret art exhibits. This was due to Stanisław Lorentz, who established an underground department of education and culture.

An inkling of hope was felt in 1953, not because something had happened, but because something hadn't: Stalin died without a succession plan. A series of political reforms in the Soviet Union hastened a thaw in Poland. Political borders began to blur. Stalinist rhetoric was replaced with a focus on left-wing nationalism, and there seemed to be a tacit agreement among Soviet officials in Poland that a renewed pursuit of Polish culture should not be taking place on the basis of external orders. Cautiously at first, Polish intellectuals reclaimed their confidence. Lorentz began to scout for cultural opportunities that would place Poland on the map again. It took him very little time to zero in on plans by European institutions to celebrate the five hundredth anniversary of Leonardo's birth.

There were seven museums that owned Leonardo's work: the Louvre, the Florentine Uffizi Gallery, the Vatican Museum, the Hermitage in St. Petersburg, the Royal Academy of London, the Liechtenstein Museum, and—in Lorentz's backyard—the Kraków Museum with Czartoryskis' *Lady with an Ermine*.

Had Tadeusz Dobrowolski paid more attention, he might have been the first to secure approval for *Lady with an Ermine* to represent Poland in the international trib-

ute to Leonardo on the five hundredth anniversary of his birth. Not only was Lorentz quick to act, but he knew how to fight his corner in a time when filling the gaps of a Communist strategy in Poland were party bureaucrats. Aware of the ambitions of the party's minister of culture in Poland, he suggested that under the right circumstances the National Museum in Warsaw might become a Polish Louvre. It was just enough sprinkled stardust for the minister to instruct a dismayed Dobrowolski to hand over *Lady with an Ermine* for an exhibit at the National Museum in Warsaw.

In anticipation of the Warsaw exhibition, it had been decided that the picture should be reframed. Making the most of a situation not of his choosing, Dobrowolski sought a respected conservator to examine *Lady with an Ermine* when it was taken out of its old frame, primarily to confirm the portrait's authenticity. The conservator was able to inspect the picture in detail by using an early version of the stereoscopic microscope—a microscope that produces a three-dimensional image of an object by focusing on the object from slightly different positions in each of two lenses. That, along with a chemical examination of ground samples of the tiny fragments gingerly lifted from the picture's edge, confirmed that Leonardo had used white lead bonded with oil, rather than plaster, to prime the walnut panel, an innovative way of priming; that there had been previous retouches; and that the background had indeed been repainted.

After the conservator concluded his examination of the picture, the minister of culture, impatient that it be trans-

ferred to Warsaw, sent his wide-bodied Chevrolet and an appointed official to collect it. Shortly after arriving in Warsaw, *Lady with an Ermine* was refitted in an elegant Renaissance frame with intricately carved rosettes at its corners. It was hung on a specially designed screen and placed under armed guard at Warsaw's National Museum. So splendid a job was done by *Lady with an Ermine* to popularize the museum and the city of Warsaw that Lorentz and the minister of culture decided not to return it. Cloaked in what was conveyed as the pursuit of additional research, the minister notified Kraków's National Museum that he had granted a loan extension of the portrait to the Warsaw museum.

Weeks turned into months with letters volleying back and forth between the museums. At some point during the two years the portrait was withheld by the National Museum in Warsaw, experts at the museum's conservation studio conducted their own chemical and physical research on it. The conclusions reached were that the panel on which it had been painted was cut from walnut; that it had been painted with thin layers of paint; and that it had kept its original size—in other words, it hadn't been cropped or trimmed. Closer analysis of Leonardo's depiction of the ermine's fur and eyes confirmed that in painting the portrait, Leonardo had used both hands. As had been the case when the portrait was examined at the Doerner Institute in Munich in 1946, it was hypothesized that the background on the right side of Cecilia might have been a window, though none were prepared to say with any strength of conviction that that was the case.

Becoming increasingly alarmed that for all intents and purposes *Lady with an Ermine* was a victim of kidnapping by the National Museum in Warsaw, officers from the museum in Kraków sent a delegation to forcibly retrieve it. After a heated confrontation, the portrait was removed from the museum and driven to the Warsaw train station. It returned to Kraków in a plushly upholstered saloon car where wet sheets were hung to moisten the air.

TWENTY-EIGHT

GEORGE ORWELL WAS THE FIRST to use the term "Cold War" in 1945, referring to what he predicted would be a nuclear stalemate between "two or three monstrous super-states, each possessed of a weapon by which millions of people can be wiped out in a few seconds." A few years later, it would become the overriding drama, during which time the United States and the Soviet Union managed to sidestep military confrontation in Europe and engage in combat operations only when it was necessary to keep allies from defecting to the other side, or to overthrow them after they had done so. Russia sent troops to preserve Communist rule in East Germany, Hungary, and Czechoslovakia, while the United States assisted in the overthrow of the left-wing government in Guatemala and in the failed invasion of Cuba.

There was an easing of tensions after the Nuclear Test-Ban Treaty was signed in 1963, and in due course Cold War certainties and its expenses were challenged in Poland, where, despite what Communism continued to promise,

the younger generation began to question its moral authority. Debatable is whether *Lady with an Ermine*'s popular appearance at the National Museum in Warsaw applied pressure for Poland's further liberalizations. Undebatable is that it caught the attention of the West, where major museums requested the portrait on loan. None received permission, for the lingering unknown for the Polish state resided in international law. The Czartoryski family still owned *Lady with an Ermine,* along with the other pictures and artifacts in their collection held at the National Museum in Kraków; moreover, the Czartoryski family had scattered its members over several continents. If the portrait—indeed, any object in the collection—resided in a country with an independent judiciary, it would be subject to sequestration and would not return to Poland.

Among the family's descendants is Count Adam Zamoyski. His grandmother was Prince Jerzy Adam Czartoryski's wife. Born in New York City in 1949, Zamoyski was brought up in England, but he is fluent in Polish. More to the point, he is in possession of dual Polish-British nationality and took it upon himself to organize a meeting in Kraków with Marek Rostworowski, the director of the Czartoryski Museum.

For years, Rostworowski, along with the collection's curators, remained committed to keeping the collection separate from Kraków's National Museum until a time when it could be repossessed by the family. In fact, some of the collection's staff had worked for the family, including Zofia Szmit, whom Zamoyski discovered was living in the museum. To justify her residency there, Zofia had been assigned token jobs.

Aware of Zamoyski's visit to the Czartoryski Museum, Soviet officials agreed that it was not worth losing *Lady with an Ermine* by allowing her to be lent to any Western museum. If, however, the portrait were to travel eastward, it would remain under Soviet jurisdiction. Explaining this to the Communist Party was Irina Antonova, who had already decided that *Lady with an Ermine* should be lent to the Pushkin State Museum of Fine Arts in Moscow. Antonova was someone not to be ignored. She would outlast every Russian leader from Stalin to Yeltsin.

———

Known for its broad selection of European works assembled from the liquidated galleries and nationalized royal and noble estates in Russia, the Pushkin State Museum of Fine Arts' only association with the Russian poet is as a posthumous commemoration. To bolster the collection, the state had at one time instructed the Hermitage Museum in St. Petersburg to contribute some of its own artworks. One masterpiece it would never agree to relinquish was *Madonna and Child with Flowers,* Leonardo's first painting as an independent young artist in Florence.

The backstories for *Madonna and Child with Flowers* and *Lady with an Ermine* were similar in several ways: both had been lost to view for more than two centuries until they were purchased in Italy in the 1790s; both of the men who purchased the paintings were foreign diplomats who returned to their homelands with the pictures.*

* The buyer of *Madonna and Child with Flowers* was a Russian connoisseur. At his death, it passed on by inheritance until it was sold a hundred years later to the prominent Benois family of Russian artists, musicians,

Irina Antonova had joined the Pushkin Museum the year World War II ended and was put in charge of it by the post-Stalin leader of the Communist Party, Nikita Khrushchev. She would remain the museum's director for four decades, making her, to this day, the oldest and the longest-serving director of a major art museum in the world. Antonova had supervised a major reconstruction of the museum, keeping secret that it was to accommodate artworks confiscated by the Russian Trophy Brigade during the last months of the war. When confronted with this untidy fact, she shifted nimbly between denial and combativeness, insisting, first, that the artwork had not been stolen and, when it was proved otherwise, insisting, next, that the artwork was exempt from restitution. The museum still holds Priam's Treasure, which had been looted by the Red Army after the Battle of Berlin.

Antonova's competitive personality was strung as tightly as a piano wire, and she resented that the museum she was running was marginalized by the Hermitage. It wasn't just the comparative scale of the two museums—with the Hermitage being the largest museum in Russia, and the Pushkin right behind it—it was that no Leonardo had ever graced its walls, not even on loan.

In 1972, Antonova decided to do something about this injustice and picked up the phone to the Kremlin. She asked for Yekaterina A. Furtseva.

Madame Furtseva—as she would come to be called by

and architects (from which the English actor and writer Peter Ustinov was descended). That family sold it to the Hermitage in 1914.

the Western press—began work in a factory as a weaver when she was a child. At thirteen, she joined the regional Young Communist League. At twenty-three, she became a member of the Communist Party, quickly advancing to party organizer. Under Stalin, she was named a candidate member of the powerful Communist Party Central Committee. Not long after, she caught the eye of Khrushchev.

Their relationship was a political two-way street.

When rivals in the Politburo sought Khrushchev's ouster at a meeting of the Central Committee, Furtseva stood to talk in his defense and continued to do so for six grueling hours. The tactic enabled other committee members, arriving late from across the Soviet Union, to continue to filter into the room and form a majority, and consensus for political reform emerged from what became one of the most important meetings in the party's history. Filibustering had no precedent in Soviet politics: Furtseva's use of it saved Khrushchev's political career. He designated her membership in the ruling inner circle of the Communist Party—the first and only woman in that role.

Awarded the position of Russia's minister of culture, Furtseva oversaw book publishing, ballet, music, and film and television production. Because she had little in common with the artistic community except a shared liking for vodka, and she lacked a formal training and—others would be quick to point out—an appreciation for Russian culture, it was believed that she would find herself in over her head. She answered her critics by commuting deftly between doing what was expected of her by the old

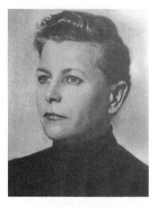

Not only did Yekaterina Furtseva achieve political longevity in Russia, but she acquired an appetite for Western glamour along the way.

guard (attacking the writings of Aleksandr Solzhenitsyn, for example) and granting commissions to avant-garde artists. As the party began to relax the state's authoritarian controls, so, too, did Furtseva begin to expand Soviet cultural exchanges to other countries. Russians were given the chance to see Hollywood movies and hear jazz; at the same time, an arrangement was negotiated wherein Sol Hurok, the late American impresario, was received by the Bolshoi Opera, and the Bolshoi Ballet made a trip to the United States.

The more Furtseva traveled outside the Soviet Union, the more she enjoyed the introductions it offered: she had tea with Pat Nixon in the White House and visited Queen Elizabeth at Buckingham Palace. As time went on, she quite literally let her hair down after years of pulling it back in a tight, twisted bun. Her manner became less austere, and she began to wear a bit of makeup. Her

conservative attire gave way to a more colorful presentation, and she traded in her government limousine for a sports car.

When Antonova contacted Furtseva requesting a "brotherly loan" of *Lady with an Ermine* for the Pushkin Museum, it required only a short letter from Furtseva to the director of the General Board of Museums in Poland for the portrait to be retrieved from the National Museum in Kraków. From Kraków, it took flight for the first time.

Eerily inventive, Leonardo had created workable designs for any number of machines hundreds of years before they became reality. Twenty pages of his notes and drawings outlined the concept of flight, concepts that were encrypted into the design of the type of plane that, five centuries later, would transport *Lady with an Ermine* from Warsaw to Moscow.

The case containing the portrait had been coated with a special varnish and taped in a way that would protect it from any condensation while in the air. Waiting on the tarmac for its arrival were Soviet officials who had been ordered to accompany it during a police-escorted, flags-fluttering car ride to the center of the city. There, standing at attention in front of the Pushkin Museum, was Moscow's deputy minister of culture. The car containing the portrait pulled up in front of him. As the crate was being removed from the car, he bowed to it in a public show of respect.

Opening the exhibit at the Pushkin Museum, which featured *Lady with an Ermine,* was a visibly happy Irina Antonova, satisfied that at last a Leonardo was hanging

on the museum's wall, albeit on loan. Also attending the opening was Yekaterina Furtseva wearing beautiful Italian shoes. But it was Cecilia Gallerani who claimed the room for herself. Some eight thousand people a day came through the museum doors for a chance to see her.

IT HAS BEEN SUGGESTED that post–World War II Polish history runs in ten- to fourteen-year periods that cycle from repression to reform and back to repression and that each period of reform ushers in the promise of economic change before, inevitably, the government drifts off course and becomes out of touch with the needs and hopes of its people.

The early 1970s in Poland began with the government's commitment to economic change. To deliver on this promise required Western machinery that was thought would revolutionize industry in Poland, and to acquire this machinery, Poland borrowed money—a great deal of it—from the West. The hoped-for outcome was that the imported machinery would facilitate the creation of opportunities for Poland to export products, which, in turn, would enable Poland to pay back its debt.

The calculated risk seemed to pay off: by the mid-1970s, Poland's economy was booming, and the Polish state decided it was an opportune time to purchase *Lady with*

an Ermine, along with the Czartoryski collection, from its inheritor, Adam Karol Czartoryski.

Things changed, and despite its early windfall the 1970s ended badly. An oil crash sent the West into an abrupt recession, resulting in monetary policies that tripled interest rates. East-West relations turned chilly, which put a stop to the détente on which Poland was so dependent. Poland's hard currency rose almost vertically. No longer able to offer cash for the purchase of *Lady with an Ermine* and the other artworks in the Czartoryski collection, Polish authorities offered an exchange of coal.

Coal—how anyone thought that this was a reasonable proposition is incomprehensible, but it was enough of a warning to the family of just how precarious the future of the museum might be.

The 1990s were defined by the Berlin Wall coming down and the reunification of Germany. For the United States and Russia, that meant stepping back from a volatile arms race; for Poland, it meant a reorientation away from the Soviet sphere. By the end of that decade the courts in Kraków recognized Prince Adam Karol Czartoryski as the sole heir to his father's estate. The ownership issue, held in abeyance for some fifty years, was finally resolved: the collection, as well as the buildings housing it, was declared Adam Karol's property.

To guarantee the museum's future required an institutional status, which was why Adam Karol renounced his personal rights to the ownership of the Czartoryski assets and transferred them to a foundation he had established: the Princes Czartoryski Foundation. It would remain under the care and administration of the National

Museum in Kraków, which would rent the buildings from the foundation.

As the foundation's chairman, Adam Zamoyski—first cousin to Prince Adam Karol Czartoryski—who by then was a respected historian and author based in London, assembled an advisory board, which included, among others, a director of London's Wallace Collection and a director of the Smithsonian National Museum of Asian Art in Washington, D.C. The newly installed board—working closely with the Polish government and employing a great deal of ingenuity—was able to ensure by legal means that the collection would never be appropriated by the state or made unavailable to the public in a permanent sense. Papers were signed, and for the first time *Lady with an Ermine* was given freedom of movement beyond the Iron Curtain.

Different countries, different cultures, different backgrounds, different education, different careers—different everything: no two figures could be less alike and less likely to cross paths than John Carter Brown III and Lech Wałęsa.

Brown was born wealthy and privileged in Providence, Rhode Island. He hailed from a prominent family whose ancestors predated the American Revolution and had donated the initial endowment for Brown University. His father was appointed assistant secretary of the navy under Harry S. Truman. Lech Wałęsa was born in Nazi-occupied Poland not long after Hans Frank hung *Lady with an Ermine* above his desk at the Wawel Royal Castle

in Kraków. Wałęsa's father, a carpenter, was interned in a forced labor camp until the end of the war and, two months later, died from exhaustion and illness. Brown graduated at the top of his class at Harvard and attended Harvard Business School. Wałęsa graduated from vocational school as a qualified electrician. Brown was hired by the National Gallery of Art in Washington, D.C. Wałęsa worked as a car mechanic before being employed as an electrician at a large Polish shipyard. At the age of thirty-four, Brown became the director of the National Gallery. At about the same time, Wałęsa lost his job at the shipyard when he helped organize illegal protests against the government that failed to deliver on its promises of a wage rise for the low-paid and a freeze on food prices. Brown became the National Gallery's longest-serving director. Wałęsa was repeatedly laid off at other companies for his continued activism and remained jobless for long periods of time. Brown was one of his country's leading public intellectuals. Wałęsa, when not jailed for organizing work-stoppage strikes or being interrogated for participating in what would become the Solidarity movement—an antibureaucratic social movement that pursued social change—was under continual surveillance by the Polish secret police.

Wałęsa received the 1983 Nobel Peace Prize shortly after being released from a Polish prison. He co-founded the Solidarity Citizens' Committee in 1988. More a political party than an advisory body, it won parliamentary seats in the newly established Polish senate. A year later, he persuaded leaders formally allied with the Communist Party to form a non-Communist coalition government;

John Carter Brown III and Lech Wałęsa.

it elected the first non-Communist prime minister of Poland in forty years. A year after that, Wałęsa won the presidential election and became the first freely elected head of state in sixty-three years. During his presidency, from 1990 to 1995, he successfully negotiated the withdrawal of Soviet troops from Poland and oversaw Poland's privatization and the transition to a free-market economy, which resulted in a substantial reduction in Poland's foreign debts.

Determined that the National Gallery would be the first museum in the West to display *Lady with an Ermine,* Brown made two trips to Kraków and appealed to the director of the Czartoryski Foundation. His proposal was twice rejected. After the second time, Brown approached President George H. W. Bush, who broached the issue with President Lech Wałęsa during a meeting in the White House.

In September 1991, *Lady with an Ermine* was issued a

passport. It was placed in a bespoke, air-conditioned box and, flanked by a police escort, driven from Kraków to the Warsaw airport. Accompanied by various Polish authorities, including Poland's minister of culture, it was flown to Washington, D.C., where with great fanfare it was featured in the National Gallery's recently opened east wing, designed by I. M. Pei. That same year, the Soviet Union collapsed, and what had been the Russian Soviet Federative Socialist Republic was renamed the Russian Federation.

———

When David Bull, an internationally renowned art conservationist, was asked to name the one painting he would hang on the wall to look at every day, he answered without hesitating.

"Oh, that's easy," he responded, as though addressing the obvious. "It would be Leonardo's *Lady with an Ermine*."

"Why so easy an answer?" was the next question.

Bull's efficient explanation consisted of three short reasons: "Because I think it's sublimely beautiful. Because it is a masterly painting of technique. Because it has an intriguing story behind it."

If only briefly and in an institutional capacity, Bull was given the opportunity to have *Lady with an Ermine* to himself, when, as the chairman of painting conservation at the National Gallery of Art in Washington, he was asked to examine the portrait following the exhibition and before it returned to Poland.

Technological advances since 1952, the year the portrait was examined in Warsaw, provided Bull with the nonin-

vasive means to take color macroscopic photographs of paint fragments in up to forty times magnification. From his examination of those fragments, Bull found traces of Leonardo's fingerprints in one of the layers of painting, confirming the fact that the paint binder was oil. He also discovered that Leonardo had made a firsthand drawing and then transferred it onto the primed wood panel. Inspecting the picture under a powerful stereoscopic microscope, Bull was unable to confirm that the background had included a window at one point, but he reconfirmed that where the outline Leonardo made of Cecilia meets the background, there was a fragment of the original background color, which was a bluish-gray, and that where the light had fallen on Cecilia, that color was brighter.

As technology progressed, so too did the understanding of how Leonardo worked. A decade after Bull's revelations, there were more discoveries from which would come insights on the perplexities of Leonardo's very nature.

BECAUSE THE POLISH MINISTRY OF CULTURE wasn't permitted to endow private foundations directly, the only way the Princes Czartoryski Foundation could become truly independent was to build capital on its own. As the foundation's breadwinner, *Lady with an Ermine* became a habitual traveler, moving from one loan venue to the next.

In some cases, like that of Washington's National Gallery, a loan was pledged by the Polish government with the purpose of enhancing Poland's image. Other times, loans were less a case of ambassadorial outreach than they were designated profit centers: that was certainly true in 1993 when the portrait was lent consecutively to two museums in Sweden. The first was in Malmö, where a German firm insured the portrait for $100 million and handled the myriad details entailed in its transport. The small, wooden, silk-lined box in which *Lady with an Ermine* traveled was refurbished before the journey to Sweden. Hours before the upgraded box containing the portrait boarded

the plane, it was placed in a fortified, airtight steel crate equipped in such a way that if the plane crashed, the crate could still be found. A special type of aircraft was chartered. Pilots trained to fly at deliberately low altitudes were hired. At other times, when not transporting donated organs, the plane and its crew's other client was Pavarotti, whose voice required the same precautions.

The plane landed at the airport near Malmö on a NATO base ringed with snipers positioned on the surrounding rooftops. An armed brigade escorted the car containing *Lady with an Ermine* to the museum, where it was quarantined in an air-controlled, constantly monitored room. Twenty-four hours later, it was welcomed to the open air by, among others, Carlo Pedretti, considered one of the world's leading experts on the life and work of Leonardo.

Transferring the portrait to Stockholm after the exhibition in Malmö had a less precise execution. *Lady with an Ermine* was kept in the basement of NATO headquarters for two weeks until sufficient security could be arranged for its transport "under arms" to an exhibition whose purpose was plainly commercial. The portrait was part of a marketing campaign by the Swedish government, which at the time was lobbying to build a sixteen-kilometer bridge over the Øresund Strait dividing Sweden and Denmark. *Leonardo's Bridges* featured *Lady with an Ermine* in an armored glass cabinet, along with thirty models of bridges, machines, and buildings designed by Leonardo.

In 1998—after some two hundred years—*Lady with an*

Ermine finally returned to Italy. Its first stop was the Quirinal Palace, which had served as the residence of thirty popes, four kings, and twelve presidents of the Italian Republic. The palace had been considered a detached and austere presence in Rome until it granted temporary access to the public in the 1980s at the unveiling of the Riace Warriors: two full-sized Greek bronzes of naked, bearded warriors cast between 460 and 450 BC, found in the sea in southern Italy in 1972, and emerging from conservation in 1981. Nearly two decades later, *Lady with an Ermine*'s public appearance at the palace would be a cultural event on the same par.

From Rome, the portrait traveled by armed convoy to its place of origin, Milan. It was exhibited at the Pinacoteca di Brera, a museum consisting primarily of important artworks from the areas of Italy conquered by Napoleon and his French armies.

The next stop returned the *Lady with an Ermine* to Florence, Leonardo's beginning as a painter. There, it was exhibited in the Palazzo Pitti, a vast palace situated on the south side of the river Arno—the same river that Leonardo had at one time plotted with Machiavelli to divert in order to resolve an ongoing conflict between Florence and Pisa. The Medici dynasty had made the palazzo into a treasure trove of art and luxury items until the ubiquitous Napoleon used it as another one of his power bases. After serving as the principal royal palace of a united Italy, it was donated, along with its contents, to the Italian people in 1919. Some eighty years later, *Lady with an Ermine* was placed on a wall facing a portrait of Ludovico and another

of Beatrice d'Este. It's safe to say that Beatrice would not have appreciated the juxtaposition.

The picture remained in Florence but was moved to the Uffizi Gallery, where an agreement had been reached: in exchange for the loan, the gallery's *La Velata* by Raphael and *Venus of Urbino* by Titian would be exhibited in Poland.

After returning to Kraków, *Lady with an Ermine* was granted a brief rest before preparing for another foreign trip. This time it would go to Japan, accompanied by other pieces from the Czartoryski Foundation's collection. *Treasures from the Princes Czartoryski Museum* began its tour at the Kyoto Municipal Museum of Art before moving on to the Matsuzakaya Art Museum Nagoya and concluding at the Yokohama Museum of Art.

On the plane returning to Poland, the curator for the Czartoryski collection and the crate containing *Lady with an Ermine* were securely strapped to their individual seats in the front of the aircraft, directly behind the pilots. The curtain between the passenger seats and the pilot cabin was drawn back, and the curator could see that during long stretches in the air the plane was on autopilot while the pilot slept and the co-pilot occupied himself by reading the newspaper.

Her debrief on the ground flagged two concerning facts to the museum officials: that between 1991 and 2002 the portrait had spent two and a half years away from Kraków; and that in the portrait's absence attendance at the Czartoryski Museum had dropped by half. Certain representatives from the foundation held to the conviction that lending the masterpiece to other museums was

an excellent promotion of the collection as well as of Kraków.

Lady with an Ermine returned to the United States in 2003 for an exhibit at the Milwaukee Art Museum. It was followed by another at the Museum of Fine Arts in Houston, and the journey from one to the other included an unforgettable incident at the Milwaukee airport. After being deposited at the curbside by police, the Polish curator and a representative from the insurance company were left to deal with security officers, who ordered that the box be taken out of its crate, opened in full view, placed on the conveyor belt, and put through the X-ray machine with other pieces of luggage.

It was after hours and the Polish embassy couldn't be reached. There was a standoff. To calm his nerves, the representative from the insurance company began to walk in circles. The curator, facing down a growing number of security personnel, did her best to maintain nonconfrontational calm while impatient passengers queuing behind her became increasingly aggravated, but when raised voices escalated to shouting, her composure came off the rails. She fired off a litany of insults at the airport's head of transportation security, whereupon the crate was taken off the conveyor belt and moved to a private room for a check witnessed by a limited number of people and without the requirement of an X-ray.

A recap of the incident went down poorly in Poland. Disapprovals were expressed about *Lady with an Ermine*'s hectic schedule with criticism coming not only from Polish experts but also from foreign specialists, who went on

the record with their concern about the portrait's fragility. The warnings were ignored when, in 2009, the portrait was lent to the National Museum in Budapest.

Lady with an Ermine remained at the National Museum in Kraków until it was sent to Madrid in 2011 for an exhibition of Polish art treasures. From there, it traveled to Berlin before taking a last trip abroad to London.

THIRTY-ONE

IN 2011, LONDON'S NATIONAL GALLERY announced a future exhibit, *Leonardo da Vinci: Painter at the Court of Milan,* wherein *Lady with an Ermine* would be showcased in what would be the most complete display of Leonardo's rare surviving paintings brought together in one space. The public's unprecedented response was such that, months ahead of the exhibition, people queued outside the gallery as early as 1:00 a.m. to purchase advance tickets in weather so cold that the water in the fountains in Trafalgar Square froze over. Advance tickets for the run of the exhibit sold out almost instantly.

The portrait was transported from Berlin in an anti-shock frame and placed in a portable environmental chamber. After quarantine, it was installed with meticulous care in the exhibit's main room on a wall behind a protective glass-fronted case. In an attempt to prevent large crowds distracting from the viewing experience, visitors were spaced out, with just so many people allowed into the room every thirty minutes.

For three months, *Lady with an Ermine* remained in the company of *La Belle Ferronnière* from the Louvre, the *Madonna Litta* from the Hermitage in St. Petersburg, and *Saint Jerome* from the Vatican Pinacoteca in Rome as part of an exhibition that would never be repeated. But, while the portrait participated in what many claim was the exhibition of the century, the family foundation that owned it was breaking apart.

There had been disagreements long before the exhibit, when the foundation's board members expressed concern with the portrait's frequent loans. It is said that Prince Adam Karol Czartoryski was keen on these exhibitions because they presented him with opportunities to travel and they lent him prestige. Count Adam Zamoyski suggested an alternative to the loans—one that would have still provided adequate funding independent of Kraków's National Museum. He proposed that the foundation enter into partnership with Poland's Ministry of Culture to create a new museum. This course of action would leave the buildings and collections in the private ownership of the foundation but at the same time enable it to become a public institution that could provide an income for itself, thereby removing the necessity of any further loans from the collection.

———

Quarrels can turn families into bitter things.

With the Czartoryskis, it began and ended with Prince Adam Karol, whose personal interests were to be found not so much in a museum as within the World Karate Fed-

eration, for which he was vice president. Born in Seville, educated in Spain and then in England, Adam Karol didn't speak Polish, nor did he spend a great deal of time in Poland; still, he felt that he had been undervalued there, that his gesture of transferring his rights to the foundation hadn't been given full credit. He grew detached from the foundation's board, which had been meeting more frequently in anticipation of renovating the museum's buildings and organizing a review of its holdings. It seems that, without giving notice, and in contravention of the foundation's statutes, the disgruntled Adam Karol dismissed the entire board, along with its advisory council. The staff was unceremoniously thrown out of their offices and replaced by functionaries from Kraków's National Museum.

Adam Karol attempted to negotiate with the Ministry of Culture along the lines that had previously been proposed by Adam Zamoyski, but he burdened the negotiation with his demand that he be given a stipend of $1 million per year—a legal impossibility, even if the ministry would agree. The idea of selling the collection and buildings to the Polish state might have appealed to Adam Karol more when, with age, he grew concerned about his personal finances. It seems without consulting anyone, he signed papers to sell the collection in 2016 to the Republic of Poland for the sum of €100 million. How that figure was arrived at remains a mystery; it was drastically below the estimated value of $2 billion. It should be noted that a Leonardo drawing of what is believed to be a bear's head and the size of a post-it sold for $12.2 million in 2021.

Despite the deeply discounted price of the state's

acquisition, its purchase was criticized by members of the public on the grounds that the money might have been better spent. It was also pointed out that by law the Czartoryski collection was already prevented from leaving Poland without authorization from its government. In an unhappy family spectacle, the endowment was challenged by Adam Karol's daughter and resulted in a lawsuit between them.

Before *Lady with an Ermine* was moved into a dedicated room within Kraków's National Museum in 2012, it was analyzed at the museum's Laboratory of Analysis and Nondestructive Investigation of Heritage Objects, the first—and still only—scientific unit of its kind in Poland. Among the laboratory's high-tech equipment is an X-ray fluorescence spectrometer that enables a determination of pigment composition. Deployed to examine *Lady with an Ermine,* it confirmed that similar pigments in the paint were used in other paintings by Leonardo and that—as was the case in all of those other paintings—the lapis lazuli used for the blue colors had been imported from Afghanistan. At the laboratory, a 3-D scanner photographed each fragment of *Lady with an Ermine.* Infrared, ultraviolet, and thermographic photographs reconfirmed the background color to be dark gray, modeled with light. Also discovered was more of what had been Leonardo's tinkering. It seems that, initially, he painted Cecilia wearing an elaborate headdress with a scalloped-edge veil knotted under her chin. He replaced the veil with another: one that was simple and transparent. Apparently, Leonardo also decided that any type of knot under her chin would be an unsightly

distraction, for he removed it and decided instead on the unusual wraparound addition of her long, straight hair.

Most surprising was the discovery that not all Leonardo's brushstrokes coincided with the final composition. This proved that he changed the concept during the course of painting Cecilia and her ermine, specifically around her hand and the ermine's head, hinting that the portrait might not have initially included the animal at all.

The mystery of the ermine was revisited two years later, in 2014, when the Leonardo Project was established in Florence. The project united anthropologists, genealogists, microbiologists, and eminent academics from various leading universities and institutions in Italy, Spain, France, and Canada. One participant was an engineer by the name of Pascal Cotte, the co-founder of Lumiere Technology in Paris. It pioneered a technique called layer amplification method, which has the capability to peel the painting like an onion, removing the surface to see what is happening inside and behind the different layers of paint. By projecting a series of intense lights on *Lady with an Ermine,* Cotte was able to analyze and reconstruct what had happened between the layers of the paint. He discovered that Leonardo painted the first version of Cecilia's portrait without the ermine and that this version was followed by two more versions, the last including a color change to the ermine's fur. The proven facts of the portrait's three stages reveal Leonardo's mind at work, specifically what appears to have been his aversion to actually finishing the paintings he began. Always for Leonardo there were questions to be answered. Might it have been that he continued to rework and improve on his paintings in order to go on thinking?

America's contribution to the Leonardo Project came from the J. Craig Venter Institute in California, which was pioneering the sequencing of the human genome. The institute also offered its research to Rockefeller University in New York. To mark the five-hundred-year anniversary of Leonardo's death, its DNA project invited biologists to collaborate by sharing innovative methods with the hope that with the use of modern detective techniques the identity of Leonardo's presumed remains would become another among the increasing number of scientific truths about him.

LEONARDO MUST HAVE KNOWN that his end was near when—nine days before—he drew up a will. At the same time, and for reasons known only to him, he destroyed any notes concerning his personal life.

He died quietly on May 2, 1519, having left instructions to be buried in the royal collegiate church of Saint-Florentin at Château d'Amboise. His remains rested there until the latter half of the sixteenth century when religious battles were followed by the French Revolution two centuries later. By the time the church of Saint-Florentin was demolished in 1808, and its tombstones were sold off, the site of Leonardo's tomb had long since been lost, and it is said that the local children played games of boules with the scattered skulls that lay about.

Exactly what had happened to Leonardo's remains was uncertain until an excavation in Amboise was arranged in 1863 with the full support of the emperor Napoleon III. It was organized by that most unusual of French impresarios, Arsène Houssaye, who had managed to gain yet another

cultural foothold as the inspector general of France's provincial museums.

Houssaye located a partial skeleton on the premises of the church of Saint-Florentin at Château d'Amboise. The incomplete skeleton included an unusually large skull, which Houssaye deemed "the beautiful head of Leonardo." Found close by were stone fragments, now lost, bearing the inscription "EO DUS VINC," the pieces of which contained some of the letters of Leonardo's full name.

Opposing accounts cast serious doubt on the skeletal remains put forward by Houssaye, but the unearthed bones that were allegedly Leonardo's were reinterred nearby in the Château d'Amboise's smaller chapel, Saint Hubert, where two epitaphs—in French and Italian—hang on the wall.

> *Under this stone*
> *rests bones*
> *collected during the*
> *excavations in the former*
> *royal chapel of Amboise*
> *among which it is surmised*
> *that there are the mortal remains of*
> *Leonardo da Vinci*

Fictional history was a field in which Houssaye was most comfortable, and even by the standards of the mid-nineteenth century his protocols were short on science and strong on lore; still, scientific advancements in genetic

testing might be able to confirm that the remains are, in fact, Leonardo's, for what has already been proven was his practice of using his fingers to blend the paint on canvas. This means that traces of his DNA have been left in certain of his paintings and that those traces can be compared with the DNA traces of what may or may not be his remains.

Specialists participating at the projects overseen in Florence and at Rockefeller University in New York are developing a technique to extract and sequence genetic material from Leonardo's relatively few paintings. *Lady with an Ermine*—which has traces of his fingerprints— might be holding on to this DNA, though it could also be that previous measures of the portrait's restoration, along with the passage of time, have obliterated any evidence of his touch.

———

Leonardo will always be shrouded in mystery, debate, and mythology. He was perpetually brilliant as a painter, sculptor, and architect, yet just fifteen paintings are attributed to him, and no sculptures or buildings by him survive. He was a well-known lute player and could improvise freely, but—apart from the beginning of a canon—no written music appears in any of his notebooks or journals. He was a seeker of beauty and, at the same time, a military and civil engineer devising diabolical methods of destruction, which included poisoned smoke. His groundbreaking anatomical papers were never published during his lifetime, nor were his treatises on the subjects of painting, water, mechanics, and plant growth. In the ravenous

information-gathering way of his mind, Leonardo sought out Benedictine monks, university professors, merchants, eminent physicians, and artillerymen.

At the time Ludovico commissioned him to paint Cecilia's portrait, Leonardo considered himself an atheist, but not unbendingly so. He was willing to contemplate two dueling theories of the soul. One theory, proposed by Plato, was that the soul has an independent existence unique to humankind and that it survives death. The other, proposed by Aristotle, was that, like any other organ, the soul is an inseparable part of the body that dies with the body.

At first, Leonardo agreed with Plato: that, with death, the soul doesn't decompose with the physical body. But apparently he couldn't abide the belief of something as abstract as the everlasting, because he changed direction and accepted Aristotle's proposition that, though the soul might constitute who we are when we are living, it dies with the body. Even this seemed to be unbearably insufficient a conclusion for Leonardo, and giving it further thought, he added a caveat: while the body is alive, the soul doesn't inhabit it as a whole, but resides instead in the body's most elevated part—the brain.

Like Leonardo, we are—all of us—ephemeral inhabitants on earth. Rather than trying to follow the soul to its incalculable destination, most of us find it easier to think of it as an insolvable riddle difficult to define and impossible to locate. His strongly held belief was that the essence of life—the *soul*—is located in the brain.

The term "*autopsy*" derives from the ancient Greek, "to

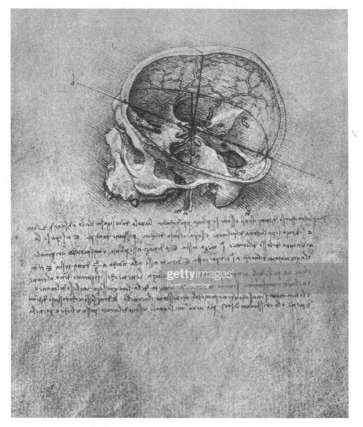

"The soul seems to reside in the judgment, and the judgment
would seem to be seated in that part where all the senses meet,"
wrote Leonardo before he began painting Cecilia's portrait.

see for oneself." It was with that intention that Leonardo
sawed a human head in half, top to bottom. In a calm and
coherent series of elegantly clear drawings, he set down
axis lines on the autopsied head, and at their intersection
he drew a cavity he thought contained the confluence of
all a human's senses.

You need not be a steward of logic to acknowledge that the common human traits of laziness and lack of imagination invite the brain to lead us into an almost surreal sense of incompetence and that no matter how impressively our brain functions at its optimal best, thanks to the traits of jealousy, prejudice, and hate it is also capable of inventing unimagined horrors.

Leonardo was starkly aware of the failings of humankind; his notebooks reveal an increasing detachment from man's illogical revulsions and insane cruelties. But he was not beyond feeling empathy, and it's not wholly unreasonable to think that in the midst of painting Cecilia, he put aside clinical note taking for the sake of something more profound for by the time Leonardo finished the portrait of Cecilia, he had made obvious that it had been his heart, not his head, that had led the way. How else could his exquisitely investigative paint strokes have revealed what was lying under the surface of Cecilia's image— her capacity to think and to feel. Her soul.

During the better part of his sixty-seven years, Leonardo remained fascinated by the relentless power of motion, proclaiming it to be "the cause of any life." He studied the ancient Greek philosopher Heraclitus, whose belief was that "everything flows and nothing abides, everything gives way, and nothing stays fixed."

Well, yes and no. Despite the fleeting nature of time and its transience, an artistic masterpiece stays fixed. *Lady with an Ermine* has endured a long and fractured journey of loss and relocation. It has managed to make its way

across borders while nations and governments have risen and fallen, while fortunes have been built and squandered, while wars have been won and lost, while begrudging political collaborations have been agreed to and then often ignored, while plagues have ravished, while secrets have been hidden and betrayals have been revealed, while everyone has their own reasons for sorrow and joy, while there have been—as there always will be—honor, deceit, and the countless contradictions of humanity.

Leonardo showed us who we are and what we aspire to be. Because he foresaw the future, we remain determined to track the apparition of his genius across the firmament. But there is a single certainty in the here and now. It is that while the past has abolished much of Leonardo's work, Cecilia and her white ermine continue to prove their steadfast relationship with time by holding our imagination. Shouldn't that be enough?

ACKNOWLEDGMENTS

I owe a debt of gratitude to quite a few people who have assisted me, big and small.

Two in particular who led me through the challenging maze of research conducted from both ends were Andrea Del Cornò at the London Library, the Italian Specialist there; and Karolina Majewska-Güde, a researcher, art critic, and curator, whose meticulous investigation into the Polish material and sources was invaluable. I am appreciative of the time and effort granted by Adam Zamoyski, who provided extensive information on the Czartoryski family during its ownership of the picture.

Kind enough to arrange introductions to museum colleagues at London's National Gallery was its director, Gabriele Finaldi: Angeliki Alexandri, Susanna Avery-Quash, Caroline Campbell, Jill Dunkerton, and Christopher Riopelle were all enormously helpful.

Providing historical perspective was Luke Syson, who heads the Fitzwilliam Museum in Cambridge; he, too, arranged introductions, a crucial one to the art historian Antonio Mazzotta. Susannah Fiennes sent me to see Philip Mould, responsible for a string of notable art discoveries. Tessa Keswick introduced me to the art historian and

author Gert-Rudolf Flick; Virginia Fraser introduced me to Anna Somers Cocks, art journalist, editor, and publisher. Making himself available was Alexander Röstel, at the Courtauld Institute of Art, where he has written about the patronage networks operating in Florence during the final decade of the fifteenth century. Ongoing encouragement came from Bob Balaban, Sara Colleton, Blythe Danner, Victoria Greenwood, Gilliam Collinsworth Hamilton, Jack Hanbury-Tenison, Judy Joo, Robert Noel, Deborah Owen, Lisa Immordino Vreeland, and Andrea Wong.

I have depended a good deal on the books and articles listed, and was fortunate indeed to have had the benefit of astute direction from my editor, Thomas Gebremedhin, and my agent, Lynn Nesbit.

TIME LINE

1450	Francesco I Sforza invests himself as Duke of Milan.
1452	Ludovico Sforza is born in Milan, the same year as Leonardo is born in Vinci.
1470	Oil paints are imported to Italy from the Netherlands.
1473	Cecilia Gallerani is born in Siena, Italy.
1475	Birth of Beatrice d'Este at Ferrara.
1476	Murder of Galeazzo Maria Sforza, Duke of Milan and Ludovico's older brother.
1480	Ludovico usurps the government of Milan and becomes regent to his nephew Gian Galeazzo Sforza.
1482	Leonardo arrives in Milan in the service of Ludovico.
1486–90 (?)	Ludovico commissions Leonardo to paint a portrait of his mistress, Cecilia Gallerani.
1491	Cecilia gives birth to Ludovico's son. Ludovico's marriage to Beatrice d'Este.
1492	Cecilia is married to Count Ludovico Carminati de' Brambilla.
1494	Death of Gian Galeazzo Sforza. Ludovico is crowned Duke of Milan.
1498	Beatrice's sister, Isabella, married to the Duke of Mantua and an avid collector, borrows *Lady with an Ermine* from Cecilia.
1499	The French march against Milan. Ludovico is ousted from power. With the death of her husband and son, Cecilia moves to Lombardy.

1514–15	Giulio Cesare della Scala, an Italian scholar, reports that *Lady with an Ermine* is seen in Cecilia's castle in Lombardy.
1519	Death of Leonardo in France at the age of sixty-seven.
1536	Death of Cecilia Gallerani in Lombardy. She is survived by three children. With no traces of *Lady with an Ermine,* one thought is that it remained in the hands of her family for the some 264 years. Suggested as well is that the painting was inventoried in the collection of Rudolf II in Prague. Yet another theory is that ownership might have been included in the collection of Cesare Bonesana di Beccaria in Milan.
1772	First partition of Poland (Russia, Prussia, Austria).
1793	Second partition of Poland (Russia, Prussia).
1795	Third partition of Poland (Russia, Prussia, Austria). To save his Polish noble family from ruin, Prince Adam Jerzy Czartoryski has no choice but to place himself in the service of Catherine the Great's court in St. Petersburg—the very government that brought his own nation to its knees.
1799–1800	While traveling through Italy, Prince Adam Jerzy purchases the painting as a present for his mother, Izabela, who founded a public museum in Pulawy—the first of its kind. During that same trip, he also purchases Raphael's *Portrait of a Young Man* and various Roman antiquities.
1801	Izabela adds "LA BELE FERONIERE" to the top corner of the portrait, erroneously identifying the woman as the mistress of François I, king of France.
1830	With unrest in Poland, *Lady with an Ermine* is removed from Pulawy and transferred for safekeeping to the family's estate in Sieniawa within the Austrian partition of Poland. After the failed November Uprising, Adam Jerzy is exiled and remains in London before establishing himself in Paris.
1843	Adam Jerzy buys the Hôtel Lambert in Paris as a family home and a base of operations for promoting Poland's independence. *Lady with an Ermine* is sent there via Dresden.

1861	Prince Adam Jerzy Czartoryski dies in Paris.
1870	When the Franco-Prussian War threatens, Adam Jerzy's son Prince Wladyslaw packs the family's artworks and sends them to Dresden, though it is speculated that he might have taken *Lady with an Ermine* with him when he fled Paris for London.
1874	The city of Kraków offers what had been the city's arsenal as a museum to the family; the picture, along with what can be retrieved from the collection, resides there once the Austro-Hungarian government formally approves the ordinance for Princess Izabela's museum.
1894	With Prince Wladyslaw's death, his son Prince Adam Ludwik becomes the head of the Czartoryski family.
1901	Prince Adam Ludwik marries a major heiress, landowner, and collector in her own right, Maria Ludwika Krasińska.
1914	In advance of World War I, she moves the most important objects to Dresden, where the family has a connection with the royal Saxon family. *Lady with an Ermine* is held by the Royal Collections.
1918	After the war, Hans Posse, director of the Royal Collections, is unwilling to return the picture. Two years of negotiation ensue.
1920	*Lady with an Ermine* finally returns to the Czartoryski Museum in Kraków.
1939	Hans Posse is appointed special art envoy to Adolf Hitler, charged with overseeing the systematic process of organizing the inventory of looted art.
	The Czartoryski Museum in Kraków prepares for the German invasion and packs sixteen crates of the most precious objects, along with *Lady with an Ermine,* and hides them in the family's estate in the eastern city of Sieniawa. The Gestapo finds the crates. A selection of the eighty-five most important items from the collection is sent to Dresden. Hans Posse decides that all of the objects are to be part of the führer's personal collection in his hometown of Linz, though it is subsequently decided that *Lady with an Ermine* will be transferred to a designated museum in Berlin for safekeeping.

1941	*Lady with an Ermine* is returned to Kraków at the request of the art lover and German governor-general, Dr. Hans Frank, where it hangs above the desk from which he organizes the train system that transports Jews to Auschwitz.
1945	When the Germans evacuate Kraków in January 1945, Frank takes *Lady with an Ermine* with him to Silesia, a Polish province occupied at the time by the Soviet Union, and then to his own holiday villa in Bavaria. The painting is discovered by Allied troops when they arrest Frank there.
1946	Frank is tried at Nuremberg. Found guilty of crimes against humanity, he is executed. Along with thousands of other artworks that had been looted by the Nazis, *Lady with an Ermine* is warehoused in a Munich Collecting Point until it's retrieved by a Polish patriot who travels from London to transport it by train to Kraków, where it is warehoused once again, this time in what has become Communist Poland.
1949	The Czartoryski collection is incorporated into the National Museum in Kraków.
1952	*Lady with an Ermine* is lent to the National Museum in Warsaw and held for two years before being reluctantly returned.
1972	The portrait travels to Russia and is exhibited at the Pushkin Museum.
1991	Polish courts recognize Prince Adam Karol Czartoryski as the sole heir to the family's collection, including *Lady with an Ermine*. He transfers everything to the newly formed Princes Czartoryski Foundation, whose collection will continue to be housed in the National Museum in Kraków.
	Lady with an Ermine is issued a passport and, for the first time, travels west, to be exhibited at the National Gallery in Washington, D.C.
1993–2011	The portrait is exhibited in Sweden, Italy, Japan, the United States, Hungary, Spain, Germany, and the UK.
2016	The Czartoryski family's entire art collection is sold and donated to the Polish government for a reported

	$105 million, said to be only 5 percent of its estimated value. *Lady with an Ermine*—now beyond price—hangs in the Kraków Museum.
2019	Five-hundred-year anniversary of Leonardo's death.
Ongoing	With the aid of advancements in identifying DNA, it is possible that *Lady with an Ermine* can confirm the human remains found in a chapel in France's Loire Valley to be Leonardo's.

PRIMARY SOURCES
AND ADDITIONAL READING

CHAPTER ONE

Clark, Kenneth. *Leonardo da Vinci.* Penguin, 1993.

Keele, K. D. "Leonardo da Vinci on Vision." *Proceedings of the Royal Society of Medicine* 48, no. 5 (1955).

CHAPTER TWO

Caferro, William. *John Hawkwood: An English Mercenary in Fourteenth-Century Italy.* Johns Hopkins University Press, 2006.

Guicciardini, Francesco. *The History of Italy.* Forgotten Press, 1984.

Procter, George. *The History of Italy.* G. B. Whittaker, 1825.

Saunders, Frances S. *Hawkwood: Diabolical Englishman.* Faber and Faber, 2005.

CHAPTER THREE

Ady, Cecilia. *A History of Milan Under the Sforza.* Methuen & Company, 1907.

Collison-Morley, Lacy. *The Story of the Sforzas.* George Routledge & Sons, 1933.

Malaguzzi Valeri, Francesco. *La corte di Ludovico il Moro: La vita privata e l'arte a Milano nella seconda metà del Quattrocento.* Ulrico Hoepli, 1913.

Noyes, Ella. *The Story of Milan.* J. M. Dent, 1908.

Shaw, Christine. *Barons and Castellans: The Military Nobility of Renaissance Italy.* Brill, 2015.

CHAPTER FOUR

Almedingen, E. M. *Leonardo da Vinci: A Portrait.* Bodley Head, 1969.

Covi, Dario A. "Four New Documents Concerning Andrea del Verrocchio." *Art Bulletin* 48, no. 1 (March 1966): 97–103.

Franzero, Carlo M. *Leonardo.* W. H. Allen, 1969.

Nuland, Sherwin B. *Leonardo da Vinci*. Weidenfeld & Nicolson, 2000.

Röstel, Alexander. "Andrea del Verrocchio in Florence and Washington." *Burlington Magazine,* Jan. 2020.

Taylor, Rachel A. *Leonardo the Florentine: A Study in Personality.* Harper & Brothers, 1928.

Vallentin, Antonina. *Leonardo da Vinci: The Tragic Pursuit of Perfection.* Gollancz, 1939.

Vasari, Giorgio. *Lives of the Most Excellent Painters, Sculptors, and Architects.* 1555. Reprint, Modern Library, 2006.

CHAPTER FIVE

Ballarin, Alessandro. *Leonardo a Milano.* Aurora, 2010.

Hart, Ivor B. *The World of Leonardo da Vinci: Man of Science, Engineer, and Dreamer of Flight.* Macdonald, 1961.

Léonard de Vinci. Hazan, 2019. Official catalog of the da Vinci exhibition at the Louvre, Oct. 24, 2019, to Feb. 24, 2020.

Lumley, Henry de. *Léonard de Vinci, pionnier de l'anatomie: Anatomie comparée, biomécanique, bionique, physiognomique.* CNRS, 2021.

Nicholl, Charles. *Leonardo da Vinci: The Flights of the Mind.* Penguin, 2007.

Tyler, Christopher W. "Evidence That Leonardo da Vinci Had Strabismus." *JAMA Ophthalmology* 137, no. 1 (2019): 82–86.

CHAPTER SIX

Hickman, Katie. *Courtesans.* HarperCollins, 2003.

Labalme, Patricia H. *Beyond Their Sex: Learned Women of the European Past.* New York University Press, 1980.

Masson, Georgina. *Courtesans of the Italian Renaissance.* Secker & Warburg, 1975.

Shell, Janice, and Grazioso Sironi. "Cecilia Gallerani: Leonardo's Lady with an Ermine." *Artibus et Historiae* 13, no. 25 (1992): 47–66. www .jstor.org/stable/1483456.

CHAPTER SEVEN

Benson, Pamela. *The Invention of the Renaissance Woman: The Challenge of Female Independence in the Literature and Thought of Italy and England.* Pennsylvania State University Press, 1992.

Boulting, William. *Women in Italy.* Methuen, 1910.

Panizza, Letizia. *Women in Italian Renaissance Culture and Society.* European Humanities Research Centre, 2000.

Pizzagalli, Daniela. *La dama con l'ermellino: Vita e passioni di Cecilia Gallerani nella Milano di Ludovico il Moro*. Rizzoli, 1999.

CHAPTER EIGHT

Cockram, Sarah D. P. *Isabella d'Este and Francesco Gonzaga: Power Sharing at the Italian Renaissance Court*. Ashgate, 2013.

Hare, Christopher. *The Most Illustrious Ladies of the Italian Renaissance*. Harper & Brothers, 1904.

Servadio, Gaia. *Renaissance Woman*. I. B. Tauris, 2005.

CHAPTER NINE

Ames-Lewis, Francis. *Isabella and Leonardo: The Artistic Relationship Between Isabella d'Este and Leonardo da Vinci, 1500–1506*. Yale University Press, 2012.

CHAPTER TEN

Arnaldi, Girolamo. *Italy and Its Invaders*. Harvard University Press, 2005.

Bradford, Sarah. *Cesare Borgia: His Life and Times*. Phoenix, 2001.

Strathern, Paul. *The Artist, the Philosopher, and the Warrior: The Intersecting Lives of da Vinci, Machiavelli, and Borgia and the World They Shaped*. Bantam, 2009.

Wałek, Janusz. "*Umizgi króla i pędzel Leonarda zaletą tego obrazu.*" *Spotkania z Zabytkami*, nos. 3–4 (2018).

Zimmermann, T. C. Price. *Paolo Giovio: The Historian and the Crisis of Sixteenth-Century Italy*. Princeton University Press, 1995.

CHAPTER ELEVEN

Fučíová, Eliška, et al., eds. *Rudolf II and Prague: The Court and the City*. Thames & Hudson, 1997.

Kaufmann, Thomas D. *The School of Prague: Painting at the Court of Rudolf II*. University of Chicago Press, 1988.

Wisse, Jacob. "*Prague During the Rule of Rudolf II (1583–1612).*" In *Heilbrunn Timeline of Art History*. Metropolitan Museum of Art, 2000–. www.metmuseum.org.

CHAPTER TWELVE

Davies, Norman. *God's Playground: A History of Poland*. 2 vols. Oxford University Press, 2005.

Zamoyski, Adam. *Poland: A History*. Harper Press, 2009.

―――――. *The Polish Way: A Thousand-Year History of the Poles and Their Culture*. John Murray, 1987.

CHAPTER THIRTEEN

Bain, R. Nisbet. *The Last King of Poland and His Contemporaries*. Methuen, 1909.

Leslie, R. F. *The History of Poland Since 1863*. Cambridge University Press, 1980.

Syrop, Konrad. *Poland in Perspective*. Robert Hale, 1982.

CHAPTER FOURTEEN

Gielgud, Adam, ed. *Memoirs of Prince Adam Czartoryski*. Remington, 1888.

Zawadzki, W. H. *A Man of Honour: Adam Czartoryski as a Statesman of Russia and Poland, 1795–1831*. Clarendon Press, 1993.

CHAPTER FIFTEEN

Bik, Katarzyna. *Najdroższa: Podwójne życie Damy z gronostajem*. Kraków, 2019.

Pauszer-Klonowska, Gabriela. *Pani na Puławach*. Warsaw, 2010.

Żygulski, Zdzisław. *Dzieje zbiorów Puławskich, Swiatynia Sybilli i Dom Gotycki*. English summary title, *History of the Pulawy Collection: The Temple of the Sibyl and the Gothic House*. Kraków, 2009.

CHAPTER SIXTEEN

Bik, Katarzyna. *Najdroższa: Podwójne życie Damy z gronostajem*. Kraków, 2019.

"Raphael's Still Missing 'Portrait of Youth,' Case Study: Provenance Series (Part IV)." Amineddoleh & Associates LLC, April 22, 2020. www.artandiplawfirm.com.

Rzepińska, Maria. *What Do We Know About "Lady with an Ermine"?* Czartoryski Museum, 1978.

Wałek, Janusz. "Umizgi króla i pędzel Leonarda zaletą tego obrazu." *Spotkania z Zabytkami*, nos. 3–4 (2018).

Żygulski, Zdzisław, ed. *Muzeum Czartoryskich: Historia i zbiory*. Kraków, 1998.

CHAPTER SEVENTEEN

Borejsza, Jerzy W. *Emigracja polska po powstaniu styczniowym*. Warsaw, 1966.

Hahn, H. H. "Die Organisation der polnischen 'Grossen Emigration,' 1831–1847." In *Nationale Bewegung und soziale Organisation*. Oldenbourg, 1978.

Kalembka, S. "Emigracje polityczne w powiedenskiej Europie." In *Europa i świat w epoce restauracji, romantyzmu i rewolucji, 1815–1849*. Warsaw, 1991.

Kukiel, Marian. *Czartoryski and European Unity, 1770–1861*. Princeton University Press, 1955.

Sasik, Florian. *Polska emigracja polityczna w Stanach Zjednoczonych, 1831–1864*. Warsaw, 1973.

CHAPTER EIGHTEEN

Delacroix, Eugène. *Selected Letters, 1813–1863*. Translated by Jean Stewart. Eyre and Spottiswoode, 1971.

Pach, Walter, trans. *The Journal of Eugène Delacroix*. Crown, 1948.

Rothschild, Guy de. *The Whims of Fortune*. Granada, 1985.

Vickers, Hugo, ed. *Alexis: The Memoirs of the Baron de Redé*. Estate of the Baron de Redé, 2005.

Wilson-Smith, Timothy. *Delacroix: A Life*. Constable, 1992.

CHAPTER NINETEEN

Fermer, Douglas. *France at Bay, 1870–1871: The Struggle for Paris*. Pen and Sword Military, 2011.

Houssaye, Arsène. *Historie de Léonard de Vinci*. Didier, 1869.

———. *Men and Women of France During the Last Century*. R. Bentley, 1852.

Knepler, Henry, ed. *Man About Paris: The Confessions of Arsène Houssaye*. Gollancz, 1972.

CHAPTER TWENTY

Howard, Michael. *The First World War*. Oxford University Press, 2003.

Stevenson, David. *1914–1918: The History of the First World War*. Penguin, 2012.

CHAPTER TWENTY-ONE

Kater, Michael. *Culture in Nazi Germany*. Yale University Press, 2019.

Mund, Heike. "Hans Posse: The Man Who Curated Hitler's Stolen Art," DW, July 14, 2020. www.dw.com.

Zweig, Stefan. *Messages from a Lost World: Europe on the Brink*. Pushkin Press, 2016.

CHAPTER TWENTY-TWO

Coutouvidis, John, and Jaime Reynolds. *Poland, 1939–1947*. Holmes & Meier, 1986.

Garrett, Patrick. *Of Fortunes and War: Clare Hollingworth, First of the Female War Correspondents*. Thistle, 2015.

Stachura, Peter D. *Poland, 1918–1945: An Interpretive and Documentary History of the Second Republic*. Routledge, 2004.

CHAPTER TWENTY-THREE

Petropoulos, Jonathan. *The Faustian Bargain: The Art World in Nazi Germany*. Oxford University Press, 2000.

CHAPTER TWENTY-FOUR

Evans, Jon. *The Nazi New Order in Poland*. Victor Gollancz, 1941.

Kołakowski, Leszek. *My Correct Views on Everything*. St. Augustine's Press, 2005.

Sands, Philippe. *East West Street*. Weidenfeld & Nicolson, 2016.

What Our Fathers Did: A Nazi Legacy. Directed by David Evans. Wildgaze Films, 2015.

CHAPTER TWENTY-FIVE

Bouchoux, Corinne. *Rose Valland: Resistance at the Museum*. Laurel Publishing, 2013.

Chanel, Gerri. *Saving Mona Lisa: The Battle to Protect the Louvre and Its Treasures from the Nazis*. Icon Books, 2018.

Edsel, Robert M. *The Greatest Treasure Hunt in History: The Story of the Monuments Men*. Scholastic Focus, 2019.

———. *Rescuing da Vinci*. Laurel Publishing, 2006.

Nicholas, Lynn H. *The Rape of Europa: The Fate of Europe's Treasures in the Third Reich and the Second World War*. Vintage Books, 1995.

CHAPTER TWENTY-SIX

Doerner, Max. *The Materials of the Artist and Their Use in Painting*. Harcourt Brace Jovanovich, 1984.

Housden, Martyn. *Hans Frank: Lebensraum and the Holocaust*. Palgrave Macmillan, 2003.

West, Rebecca. *A Train of Powder*. Viking Press, 1955.

CHAPTER TWENTY-SEVEN

Ascherson, Neal. *The Struggles for Poland*. Michael Joseph, 1987.

Kemp-Welch, A. *Poland Under Communism: A Cold War History*. Cambridge University Press, 2008.

Konwicki, Tadeusz. *The Polish Complex*. Farrar, Straus Giroux, 1982.

Krystyna, Kersten. *The Establishment of Communist Rule in Poland, 1943–1948*. University of California Press, 1991.

CHAPTER TWENTY-EIGHT

Kuncewiczowa, Maria, ed. *The Modern Polish Mind*. Secker & Warburg, 1962.

Miłosz, Czesław. *The Captive Mind*. Penguin, 1981.

Szczypiorski, Andrzej. *The Polish Ordeal*. Croom Helm, 1982.

Westad, Odd Arne. *The Cold War*. Basic Books, 2017.

CHAPTER TWENTY-NINE

Ascherson, Neal. *The Polish August*. Viking, 1982.

Bull, David. "Leonardo: *Lady with an Ermine:* Preservation and Scientific Examinations." *Art Galleries*, 1992.

Garton Ash, Timothy *The Polish Revolution: Solidarity, 1980–82*. Jonathan Cape, 1983.

MacShane, Denis. *Solidarity: Poland's Independent Trade Union*. Spokesman, 1981.

CHAPTER THIRTY

Czop, Janusz, and Joanna Sobczyk. "The Travels of the Lady—the Lady Travels." *Papers of the National Museum in Krakow*, n.s., 8 (2015): 185–227.

Rostworowski, Marek. *Gry o Dame*. Suszczynski, 1994.

Zamoyski, Adam. *The Czartoryski Museum*. Azimuth Editions on behalf of the Princes Czartoryski Foundation, 2001.

CHAPTER THIRTY-ONE

Barone, Juliana, and Susanna Avery-Quash, eds. *Leonardo in Britain: Collections and Historical Reception*. Olschki, 2019.

Cotte, Pascal. *Lumière on "The Lady with an Ermine," by Leonardo da Vinci: Unprecedented Discoveries*. Vinci, 2014.

Prausnitz, John M. "The Leonardo Project." Chemical and Biomolecular Engineering Department and Center for Studies in Higher Education, University of California, Berkeley.

Syson, Luke, and Larry Keith. *Leonardo da Vinci: Painting at the Court of Milan*. National Gallery Company, 2011.

CHAPTER THIRTY-TWO

Isaacson, Walter. *Leonardo da Vinci*. Simon & Schuster, 2018.

Kemp, Martin. *Living with Leonardo: Fifty Years of Sanity and Insanity in the Art World and Beyond*. Thames & Hudson, 2018.

Roeck, Bernd. *Leonardo: Der Mann, der alles wissen wollte*. C. H. Beck, 2019.

ILLUSTRATION CREDITS

Hans Frank. Photo by the German Federal Archives via Wikimedia Commons.

Lady with an Ermine. Frank Zöllner via Wikimedia Commons

The Visconti coat of arms. Photo by G.dallorto via Wikimedia Commons

Ludovico Maria Sforza. Photo © Giancarlo Costa / Bridgeman Images

The Sforza castello. Photo by Alamy / Classic Collection

Fifteenth-century Italian workshop. Jan van der Straet © The Trustees of the British Museum

Leonardo da Vinci as David. Photo by Tutt'Art

Leonardo da Vinci's notebook. Photo by Luc Viatour via Wikimedia Commons

Bust of Beatrice d'Este. Photo by Sailko via Wikimedia Commons

Detail of *Lady with an Ermine.* Public domain via Wikimedia Commons

Isabella d'Este's commemorative coin. Photo © The Trustees of the British Museum

La Belle Ferronnière. Photo by the Yorck Project via Wikimedia Commons

Leonardo da Vinci's sketch of Isabella d'Este. Public domain via Wikimedia Commons

Cesare Borgia. Public domain via Wikimedia Commons

Thomas More and family. Hans Holbein the Younger, public domain via Wikimedia Commons

Rudolf II of Habsburg. Giuseppe Arcimboldo, public domain via Wikimedia Commons

The Blue Palace in Warsaw. Bernardo Bellotto, public domain via Wikimedia Commons

Prince Adam Kazimierz Czartoryski. Élisabeth Vigée Le Brun, public domain via Wikimedia Commons

Izabela Czartoryska. Alexander Roslin, public domain via Wikimedia Commons

Chart courtesy of the author

Duke Armand-Louis de Lauzun. Joseph Désiré Court, public domain via Wikimedia Commons

Nikolai Repnin. Public domain via Wikimedia Commons

Prince Adam Jerzy Czartoryski. Photo by agefotostock / Alamy

Czartoryski residence in Pulawy. Public domain via Wikimedia Commons

Izabela Czartoryska's private museum. Public domain via Wikimedia Commons

Izabela Czartoryska's Gothic House. Photo by Cassagne on the basis of a drawing by Barbara Czernof, public domain, via Wikimedia Commons

The Polish Prometheus. Horace Vernet, public domain via Wikimedia Commons

Chopin's Polonaise—a Ball in Hôtel Lambert. Teofil Kwiatkowksi, public domain, via Wikimedia Commons

Prince Adam Jerzy, center, with sons. Public domain via Wikimedia Commons

Arsène Houssaye. André Gill, public domain via Wikimedia Commons

Czartoryski Museum. Photo by Zygmunt Put via Wikimedia Commons

Countess Maria Ludwika Krasińska. Photo by Alchetron

Hans Posse. Photo by Sueddeutsche Zeitung / Alamy

Clare Hollingworth. Photo originally published in *The Guardian*

Wawel Royal Castle under German occupation. Public domain

The Czartoryski agricultural estate in Sieniawa. Public domain via Podkarpacka Biblioteka Cyfrowa

Zofia Szmit. Public domain

Dresden after firebombing. Public domain

Rose Valland. Public domain

Hitler's personal art collection in a refuge in the East. Public domain via Wikimedia Commons

Neuschwanstein Castle in Bavaria, Germany. Public domain via Wikipedia

A painting's wooden cradle. Photo by H.L. Stokes via Wikimedia Commons at the following license: https://en.wikipedia.org/wiki/File:Cradled_panel_painting,_Aert_van_der_Neer.jpg#filelinks

Karol Estreicher holding *Lady with an Ermine*. Photo by Shawshots / Alamy Stock Photo

Yekaterina Furtseva. Photographer unknown.

John Carter Brown III. Photo by Michael Geissinger via Library of Congress, www.loc.gov/item/2018651364/.

Lech Wałęsa. Photographer unknown

Sketch of a skull by Leonardo da Vinci. Photo by Heritage Image Partnership Ltd / Alamy

Endpaper with *Lady with an Ermine*. Frank Zöllner via Wikimedia Commons

ABOUT THE AUTHOR

Eden Collinsworth is a former media executive and chief of staff of a global think tank. She has published three previous books and currently lives in London.